IMAGES
of America

EASTERN
NORTH CAROLINA
FARMING

Merry
christmas

Thanks!
Phil Zanow

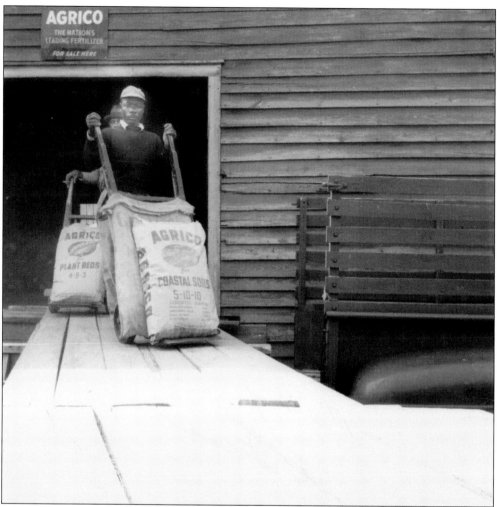

Fertilizer for many years came in 200-pound bags, as seen in this 1930s photograph of men loading fertilizer out of a warehouse. Gradually, the 200-pound bags gave way to 100-pound bags by the 1950s. Later, bagged fertilizer disappeared in lieu of liquid fertilizer. (Courtesy of Frank Stephenson.)

ON THE COVER: Eastern North Carolina farmers grew a wide variety of field crops and vegetables such as tobacco, peanuts, cotton, corn, soybeans, sweet potatoes, Irish potatoes, watermelons, and cucumbers to support their families. Cucumbers that were grown on eastern North Carolina farms were usually marketed at nearby cucumber-buying stations such as the Charles L. Revelle Sr. buying station in Murfreesboro, seen in this late-1930s photograph. The farm or peach bushel baskets shown in this photograph were made at the "world's largest basket factory," Riverside Manufacturing Company, located in Murfreesboro. (Courtesy of Frank Stephenson.)

IMAGES
of America

EASTERN
NORTH CAROLINA
FARMING

Frank Stephenson and Barbara Nichols Mulder

ARCADIA
PUBLISHING

Published by Arcadia Publishing
Charleston, South Carolina

Printed in the United States of America

Library of Congress Control Number: 2013956387

For all general information, please contact Arcadia Publishing:
Telephone 843-853-2070
Fax 843-853-0044
E-mail sales@arcadiapublishing.com
For customer service and orders:
Toll-Free 1-888-313-2665

Visit us on the Internet at www.arcadiapublishing.com

This book is dedicated to the all of the people who grew up on eastern North Carolina farms.

CONTENTS

ACKNOWLEDGMENTS

The authors would like to extend their sincere appreciation and deep gratitude to the following for providing archival photographs for this book. These photographs provide deep insight into eastern North Carolina farm life, farm practices, and farm implements 75 to 100 years ago: Don Vann, Las Vegas, Nevada; Robert A Newsome Jr., Cofield, North Carolina; Beth Stephenson Jenkins, Como, North Carolina; Virgia Burkett Nichols, Ahoskie, North Carolina; Renee Tyree, Murfreesboro, North Carolina; and the Hertford County Agricultural Extension Service, Winton, North Carolina.

INTRODUCTION

As one of the original 13 colonies, North Carolina grew from a simple agrarian- and maritime-based economy into one of the great farming states in the United States, featuring over 288,000 family farms at its peak in 1950. A high percentage of these farms were located in eastern North Carolina, where good soil, excellent growing conditions, and thousands of hardworking and God-fearing farm families were in great supply. North Carolina's rise as one of the top farming states can be directly traced to the huge quantities of farm products that were grown in eastern North Carolina by thousands of farm families residing on small family farms. Farming in eastern North Carolina developed into a way of life and culture of its own that was tough, hard, and never-ending, as there was always work to do on the farm. The number-one issue on family farms in eastern North Carolina was survival, as farmers were at the mercy of drought, flooding rains, hail, hurricanes, and poor market conditions. Life on the farm in eastern North Carolina involved a lot of hard work for every member of the family. Each family member had specific jobs to do, such as feeding the chickens, milking the cows, slopping the hogs, or chopping the firewood, in addition to the long hours spent in the fields. Each farm had to be self-supporting or it could not survive. Eastern North Carolina farm families were hardy souls and survivors, and they developed ways and means to survive almost any adverse condition.

The eastern North Carolina farm families whose strong work ethics produced huge quantities of labor-intensive row crops for their region found their lives revolving around their farms, their homes, their schools, and their churches. Their lives were influenced by such North Carolina icons as Rev. Billy Graham, Andy Griffith, Richard Petty, Dean Smith, and Michael Jordan. It was the fruits of their farm labors, in part, that produced two world-class universities, Duke University and Wake Forest University, which were funded by the Duke and Reynolds tobacco families, respectively.

While many different crops have been grown and continue to be grown in eastern North Carolina, row crops such as tobacco, peanuts, cotton, corn, and soybeans were prevalent in the past, with tobacco leading the way. Tobacco has been grown in North Carolina for almost three centuries, since its early association with Sir Walter Raleigh. In the early years of the colony and, later, the state, growing tobacco had been moderately successful. But that all changed in the late 19th century when Washington Duke's son James Duke incorporated James Bonsack's cigarette-making machine into their cigarette-manufacturing operation. This new technology in cigarette manufacturing, which could make 120,000 cigarettes a day, was a major factor in North Carolina becoming the world's largest tobacco grower. This was fueled by such North Carolina tobacco giants as the American Tobacco Company and the R.J. Reynolds Tobacco Company, which were founded by the Duke and Reynolds families, respectively. The high demand for tobacco that was fueled by these tobacco manufacturing giants saw dramatic growth in North Carolina's four tobacco belts: the old belt, the middle belt, the border belt, and the largest, the eastern belt, which alone featured nearly 70 tobacco marketing warehouses.

North Carolina has a long history of being one of the leading producers of peanuts in the United States. Eastern North Carolina, in particular, has been and remains one of the leading producers of the large Virginia-type (cocktail) peanuts, which are very popular roasted or salted. The growth of the peanut-growing industry in eastern North Carolina was enhanced in part by the closeness to the world's largest peanut market in nearby Suffolk, Virginia. Eastern North Carolina peanuts, in turn, fueled the giant Suffolk peanut market, particularly after Amedeo Obici and Mario Peruzzi formed Planters Peanut Company and built a new peanut processing plant in Suffolk in 1913. Obici and Peruzzi dramatically increased the demand for Virginia-type peanuts grown in eastern North Carolina. Planters Peanut Company, using huge quantities of eastern North Carolina–grown peanuts, soon developed into the world's largest producer of peanut products, including salted peanuts, roasted peanuts, and peanut butter, primarily through their iconic Mr. Peanut advertising slogan. It is very clear that the huge quantities of the large, Virginia-type peanuts grown in eastern North Carolina played a major role in making Suffolk the "Peanut Capital of the World."

Suffolk was not the only town in Virginia to substantially benefit from farm-related products that were grown in large quantities in nearby eastern North Carolina. In 1936, Joseph W. Lewter and Joseph Jr. founded Smithfield Packing Company in Smithfield, Virginia, only a few miles northwest of Suffolk. Importing hundreds of thousands of eastern North Carolina–grown hogs, Smithfield Packing Company soon developed into one of the world's leading producers of pork products such as bacon, sausage, and country hams. In order to achieve this, Smithfield Packing Company operated scores of hog-buying stations throughout eastern North Carolina.

Eastern North Carolina also played a prominent role in North Carolina becoming the fourth-largest producer of cotton in the United States. Cotton grown in eastern North Carolina fueled North Carolina's huge textile manufacturing industry, which included such companies as Hanes, Cone, Cannon, Fieldcrest, and Burlington. Scores of small cotton gins were located in many small towns across eastern North Carolina.

Today, North Carolina has over 57,000 farms, as compared to over 288,000 in 1950. The dramatic drop in the number of farms is due in large measure to the huge advances in the technology of farm equipment and farm practices. Equipment and practices that were the norm 50 years ago have all but disappeared from the eastern North Carolina farming scene. The drop in the number of farms is also due in part to the industrialization of North Carolina, with manufacturing employment replacing outdated, labor-intensive farm jobs, particularly in tobacco farming. In recent years, North Carolina has also seen a diversification in the farm products grown in the state. This diversification includes sweet potatoes, watermelons, wheat, hay, blueberries, strawberries, tomatoes, cucumbers, and Christmas trees. Broilers, hogs, pigs, turkeys, trout, cattle, and calves are also a part of this diversification.

One

KING OF TOBACCO ROAD

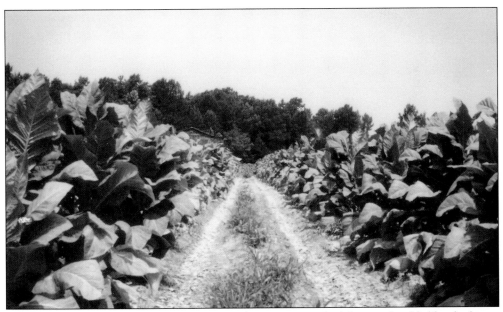

This 1950s photograph of a field of mature tobacco is typical of thousands of fields of tobacco that can be found across eastern North Carolina during the tobacco growing season. The rich, green tobacco leaves slowly become a golden color, and they were, and still are, as valuable to North Carolina's economy as gold itself. Money from eastern North Carolina–grown tobacco has greatly enhanced North Carolina's way of life, through the funding of schools, hospitals, colleges, universities, cultural and community-based improvement projects, and much more. (Photograph by Frank Stephenson.)

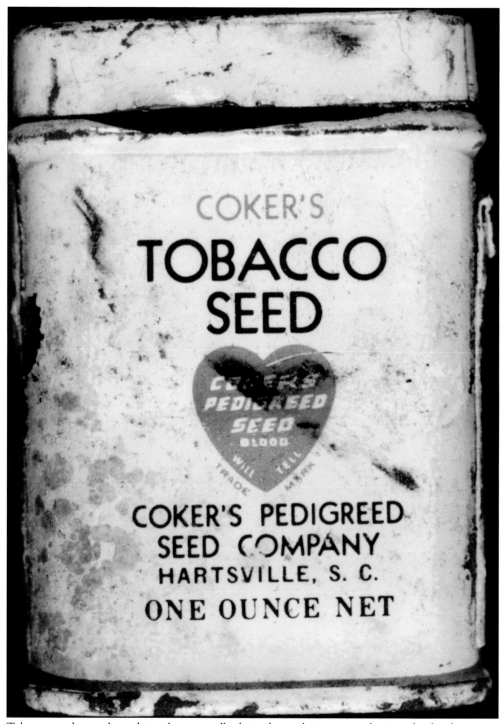

Tobacco seeds are planted in tobacco seedbeds in the midwinter months in order for the young tobacco plants to be ready for transplanting in tobacco fields in late spring. One of the main sources of tobacco seeds for many years was Coker's Pedigreed Seed Company, in Hartsville, South Carolina. (Courtesy of Barbara Nichols Mulder.)

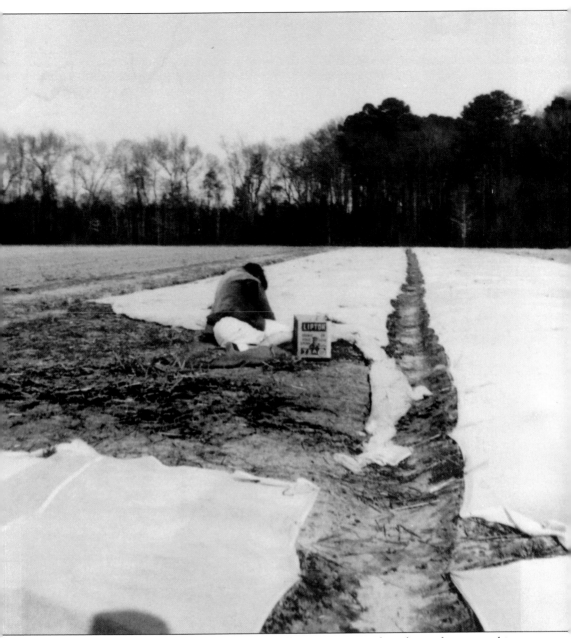

Tobacco seedbeds had to be monitored very carefully to prevent weeds and grass from overtaking the young tobacco plants. This process was time-consuming and tedious, as seen in this 1950s photograph of Velner Nichols of Ahoskie picking the tobacco bed on the Ross Nichols farm. (Courtesy of Barbara Nichols Mulder.)

When the covers are removed from the tobacco beds in the spring, tobacco farmers are delighted to see a bed full of young tobacco plants, as seen in this Hertford County tobacco bed in the 1960s. (Photograph by Frank Stephenson.)

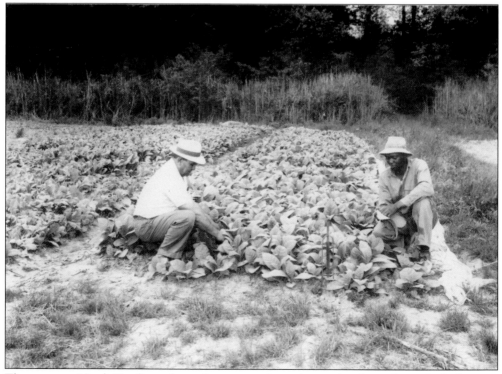

These eastern North Carolina tobacco farmers are shown inspecting their tobacco bed of mature tobacco plants that are ready to be transplanted. (Courtesy of Frank Stephenson.)

12

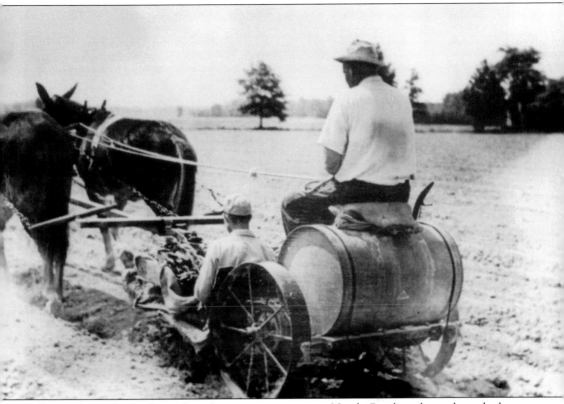

Millions of pounds of tobacco have been grown in eastern North Carolina down through the years. The process of transplanting young tobacco plants from the tobacco bed to the tobacco fields was a long, slow process and was originally done by hand. Gradually, the transplanting process began to be mechanized, as shown in this 1950s photograph of a horse- or mule-drawn tobacco transplanter. (Courtesy of Frank Stephenson.)

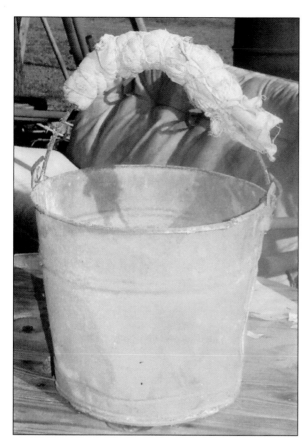

This bucket was used in the process of providing water to newly transplanted replacement tobacco plants and to carry tobacco plants to the tobacco field. Young tobacco plants require a lot of water to survive, and much of this was done by hand. (Courtesy of Barbara Nichols Mulder.)

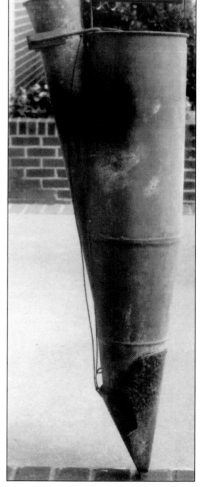

This handheld tobacco transplanter was used to transplant replacement tobacco plants. The point of this transplanter was gently pushed into the row of tobacco plants, and a replacement tobacco plant and a small quantity of water were deposited simultaneously. (Courtesy of Frank Stephenson.)

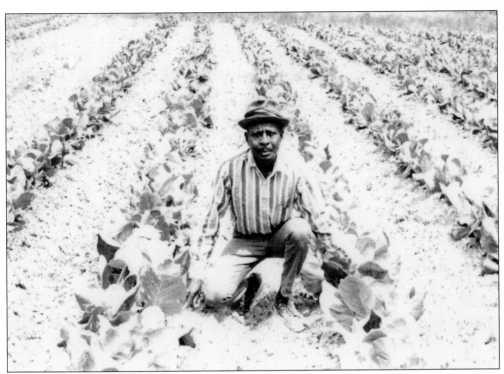

Eastern North Carolina tobacco farmers were proud of their fields of tobacco, particularly when the tobacco crop looked really good. (Courtesy of Frank Stephenson.)

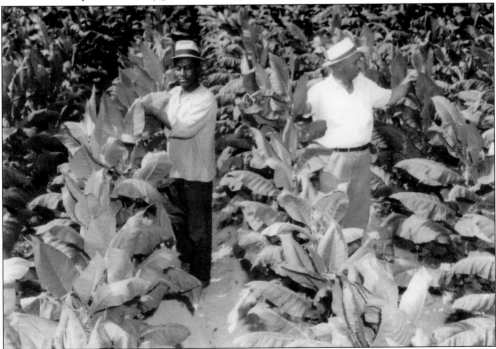

In this 1950s photograph, two Hertford County tobacco farmers are shown inspecting their field of mature tobacco, which is almost ready to harvest. (Courtesy of Frank Stephenson.)

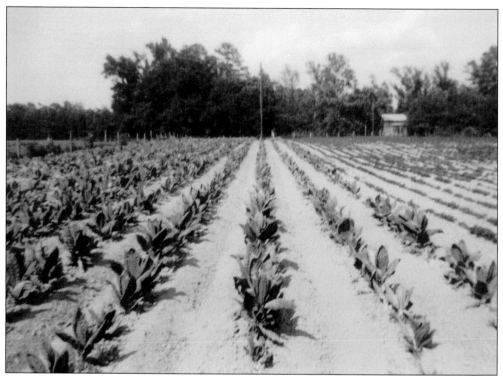

This 1955 photograph shows a field of young, healthy-looking tobacco plants in Hertford County. (Photograph by Frank Stephenson.)

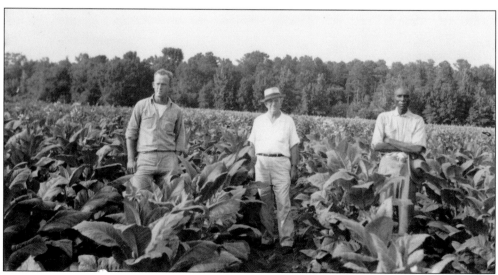

Eastern North Carolina tobacco plants could grow very large, as seen in this 1950s photograph of tobacco farmers checking their tobacco field. (Courtesy of Frank Stephenson.)

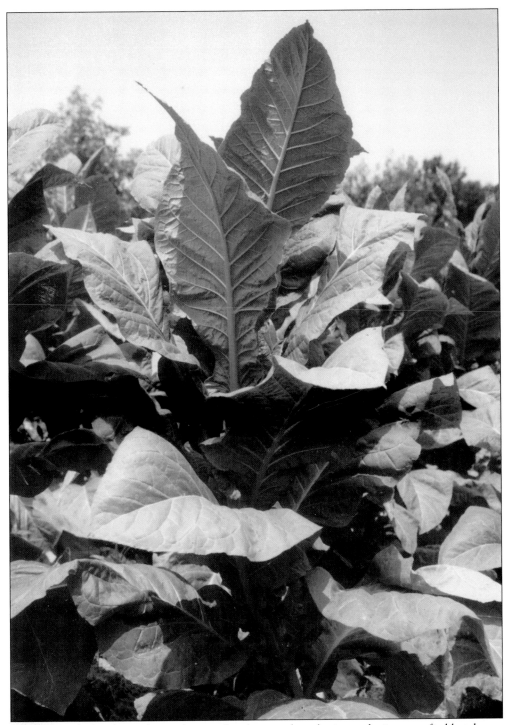

Eastern North Carolina tobacco farmers faced many obstacles in producing a profitable tobacco crop. These obstacles included drought, high winds, too much water, and tobacco worms and other insects. This 1950s photograph shows very mature tobacco prior to harvesting. (Photograph by Frank Stephenson.)

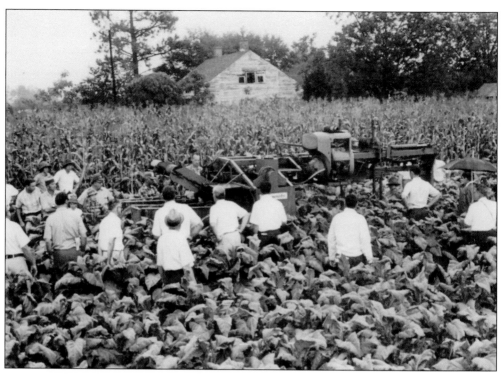

Since tobacco harvesting was labor-intensive and time-consuming, efforts began in the late 1950s and 1960s to develop a mechanical tobacco harvester in eastern North Carolina, as seen in this mid-1960s photograph. (Courtesy of Frank Stephenson.)

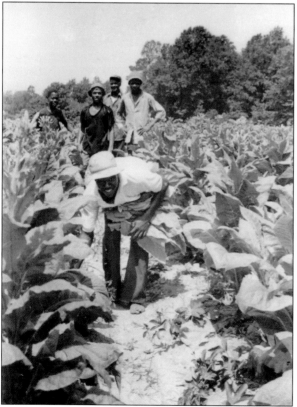

At the peak of the growing season, mature tobacco plants become a deep, rich, dark-green color. This dark-green color gives way to bright golden color prior to the tobacco leaves being harvested. The harvest begins with the very bottom leaves (sand lugs), and all of the leaves on each tobacco stalk are gradually harvested over a period of weeks. (Courtesy of Frank Stephenson.)

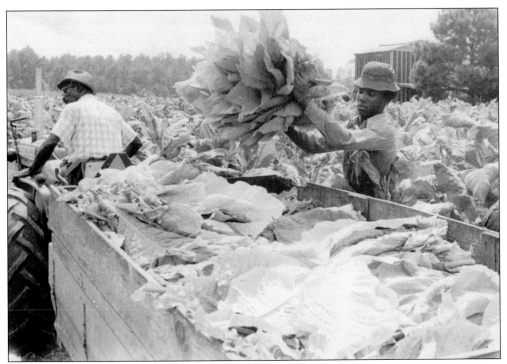

Tobacco farming requires a large amount of labor, from transplanting to harvesting to preparing for market. This 1960s photograph shows men pulling, or priming, green tobacco for curing. (Courtesy of Frank Stephenson.)

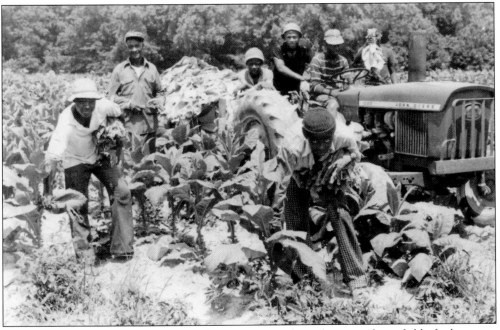

Pulling, or priming, tobacco requires a large crew in order to harvest a large field of tobacco, as seen in this 1970s photograph. (Courtesy of Frank Stephenson.)

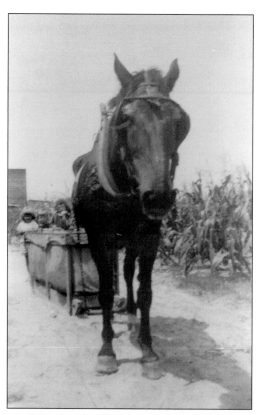

Riding on the back of a tobacco sleigh was always a lot of fun, as seen in this 1950s photograph of the three Nichols sisters, from left to right, Delores, Linda, and Barbara, of the Earlys Station community of Hertford County. (Courtesy of Barbara Nichols Mulder.)

Every member of the family contributed to the farm process, as seen in this photograph of two young brothers holding a large leaf of harvested tobacco. The two boys are standing in front of a tobacco sled, or sleigh, full of freshly harvested tobacco. (Courtesy of Frank Stephenson.)

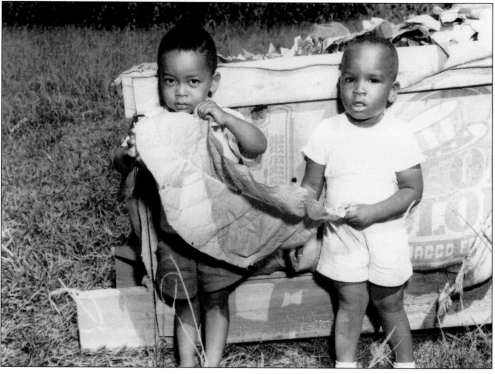

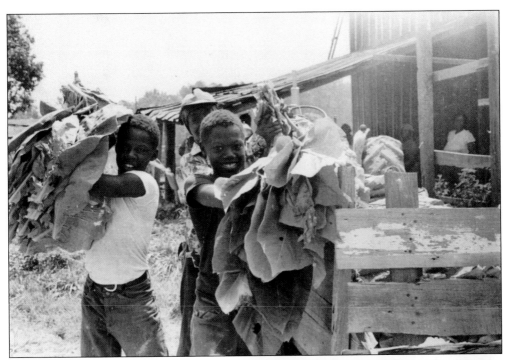

Two young boys are seen unloading freshly harvested tobacco for placement on the tying bench at the tobacco barn. (Courtesy of Frank Stephenson.)

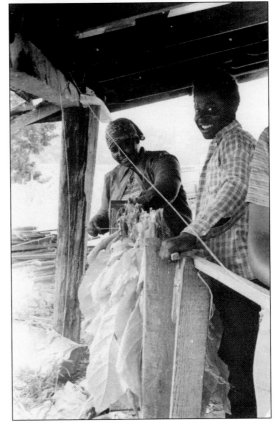

Freshly harvested tobacco was brought from the tobacco fields and tied on tobacco sticks for curing in tobacco barns. Each bundle of green tobacco that is tied on the tobacco sticks contains three or four tobacco leaves. (Courtesy of Frank Stephenson.)

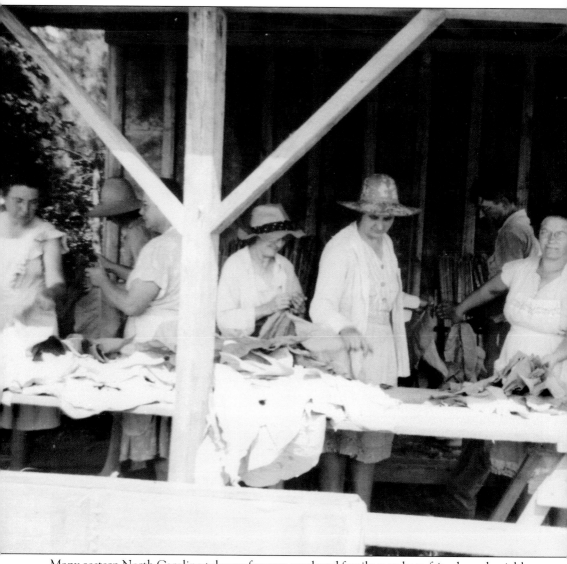

Many eastern North Carolina tobacco farmers employed family members, friends, and neighbors to work in the harvesting of tobacco. (Courtesy of Frank Stephenson.)

Freshly harvested tobacco is being tied, or looped, on a tobacco stick for curing by Anita Newsome in August 1954. The heavily laden tobacco sticks were placed in tobacco barns for curing at a high heat over a period of four to five days, which transformed the leaves from a deep green color to a golden color. The golden tobacco leaves were often called gold dollars. (Courtesy of Frank Stephenson.)

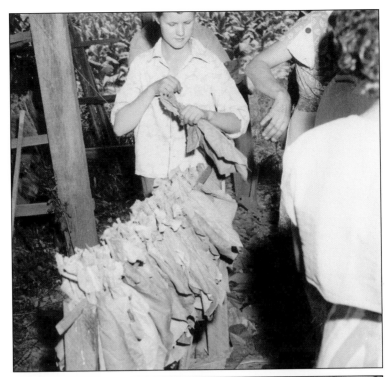

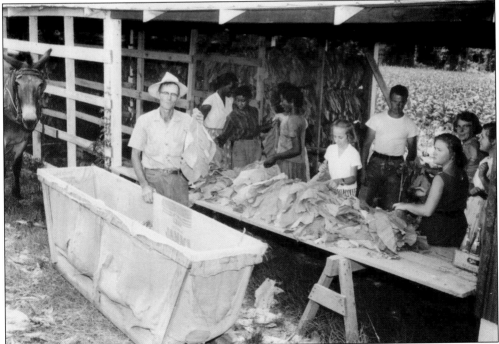

Tobacco sleighs full of freshly harvested tobacco leaves were pulled up to the tobacco barn, where the leaves were tied on tobacco sticks for curing in the tobacco barn. In July 1957, Paul S. Nichols and his tobacco crew in Hertford County are seen "putting in" tobacco the old-fashioned way. (Courtesy of Alice Nichols Cale.)

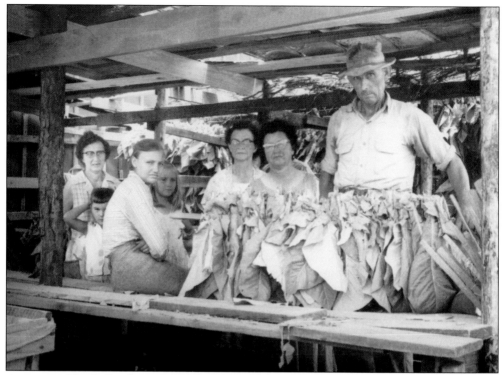

An eastern North Carolina tobacco farmer and his crew proudly display a tobacco stick full of freshly harvested looped, or tied, tobacco. The tying of freshly harvested tobacco was one of many steps that were required to get the tobacco from the field to the tobacco market. (Courtesy of Frank Stephenson.)

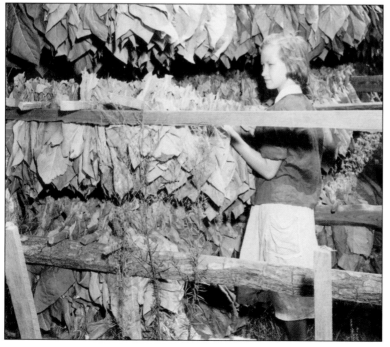

After the freshly harvested tobacco leaves were tied on tobacco sticks, the sticks were placed on a holding rack until they were hung up in the tobacco barn for curing, as seen in this 1954 photograph. (Courtesy of Frank Stephenson.)

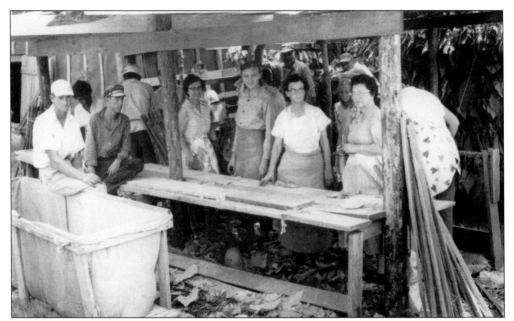

This eastern North Carolina tobacco looping crew waits for another full tobacco sleigh to arrive from the tobacco field. These breaks were few and far between. Harvesting tobacco required a huge amount of labor that involved all members of the household, including parents, aunts, uncles, children, and neighbors. Many tobacco farmers shared labor, as tobacco farm families would help each harvest tobacco on different days of the week. (Courtesy of Frank Stephenson.)

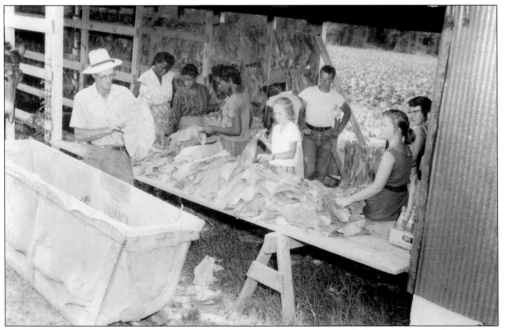

Freshly harvested tobacco leaves are being looped on tobacco sticks for hanging up in the tobacco barn for curing. There was an art to looping tobacco on a stick, as it had to be done exactly right or leaves could fall down on tobacco-curing heaters and catch the tobacco barn on fire. (Courtesy of Alice Nichols Cale.)

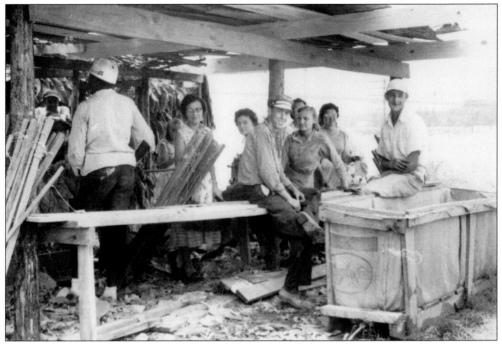

This tobacco looping crew was waiting for another tobacco sleigh full of freshly harvested tobacco to arrive from the tobacco field. A moment like this would provide the looping crew with a rare break from the long and boring process of looping tobacco. (Courtesy of Frank Stephenson.)

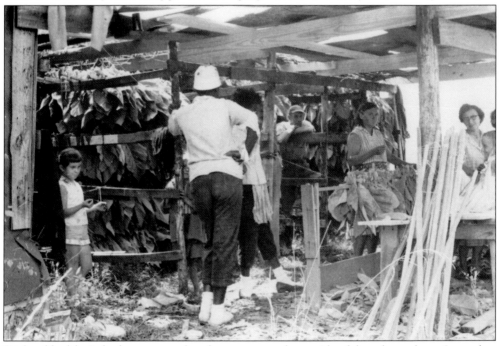

Sticks of freshly tied tobacco were placed on storage racks outside of the tobacco barn. Later that same day, the sticks of looped tobacco were hung up in the tobacco barn for curing. (Courtesy of Frank Stephenson.)

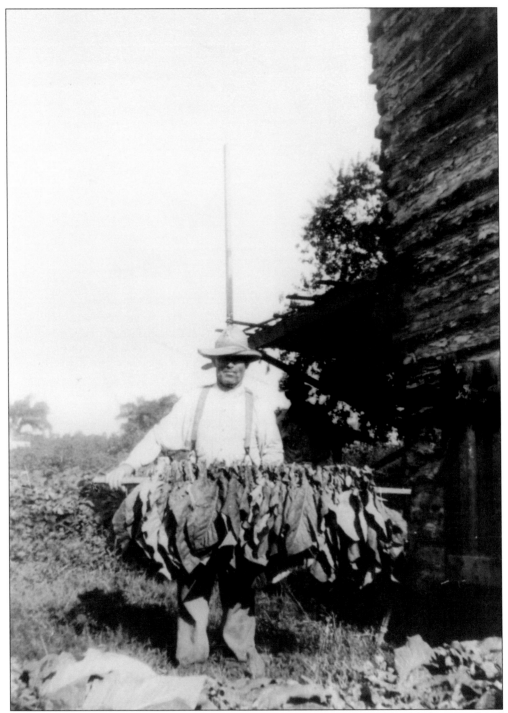

Tobacco farmer Alonzo Nichols of Ahoskie proudly displays a stick of freshly harvested and looped tobacco just prior to it being hung in the tobacco barn for curing. (Courtesy of Barbara Nichols Mulder.)

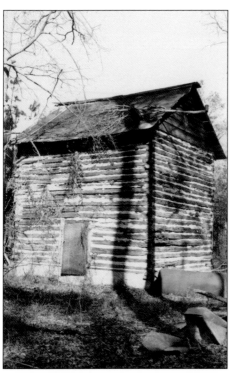

Tobacco curing barns in eastern North Carolina were constructed out of a number of different building materials. The earliest tobacco curing barns were of chinked-log construction. (Photograph by Frank Stephenson.)

Hundreds of tobacco curing barns in eastern North Carolina were covered with tar paper, as seen with this 1950s tobacco barn. (Photograph by Frank Stephenson.)

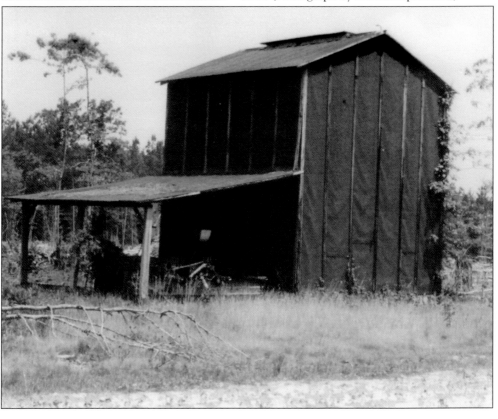

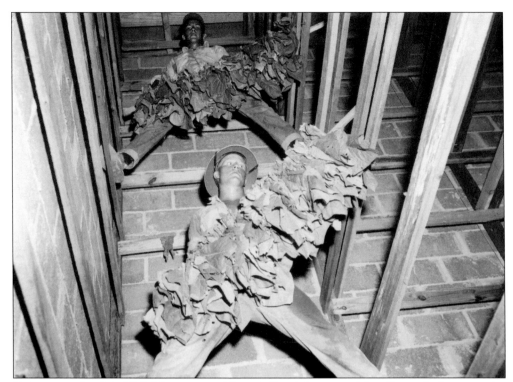

Doing a very hot job, Eddie Newsome and Bootsie Burch hang up sticks of looped tobacco on tier poles in the Ross Nichols tobacco barn for curing. The curing process subjected freshly harvested tobacco leaves to high heat for four to five days. (Courtesy of Barbara Nichols Mulder.)

Cecil Newsome and Thomas Lewis of the Ross Nichols tobacco harvesting crew are seen hanging up sticks of freshly looped tobacco in the tobacco barn for curing. (Courtesy of Barbara Nichols Mulder.)

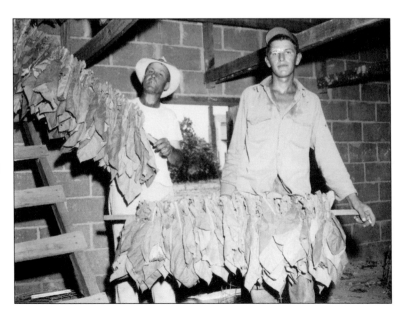

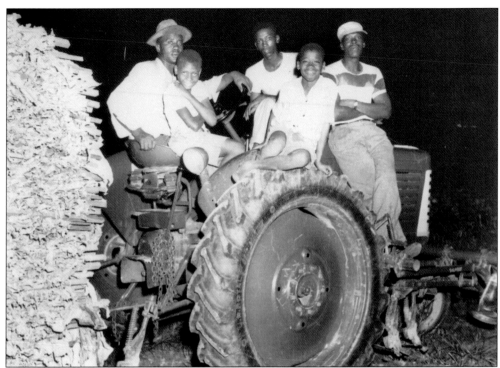

After the freshly harvested tobacco had been cured in the tobacco curing barn, it was then moved to the tobacco pack house for grading and preparation for transport to the tobacco market. This photograph shows a tobacco crew moving the cured sticks of tobacco from the tobacco curing barn to the pack house. The process of moving cured tobacco from the tobacco barn often occurred at night or in the early morning. (Courtesy of Frank Stephenson.)

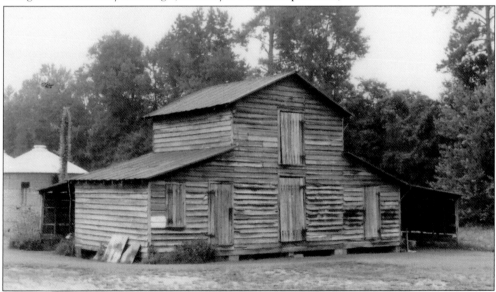

Many different kinds of farm buildings were used for tobacco pack houses. This all-purpose barn on the Frank Stephenson farm in Hertford County was utilized as a tobacco pack house a number of times. (Photograph by Frank Stephenson.)

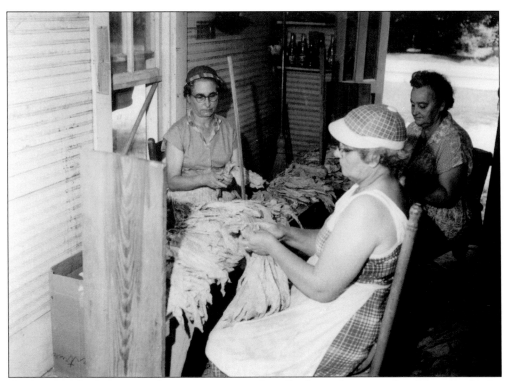

Grading cured tobacco was a long, tiring process that all tobacco farmers endured for years. In the grading process, the cured tobacco was usually divided into four grades, with the fourth grade being mostly trash tobacco. The higher the grade the more money the tobacco brought at the tobacco auction sale. The grading was usually done in the pack house, because that was where the cured tobacco had been packed down when it was removed from the curing barn. These three ladies from the Harrellsville area are grading cured tobacco. (Photograph by Frank Stephenson.)

Eastern North Carolina farm families were always proud of the crops they grew, regardless of whether it was tobacco, corn, cotton, peanuts, or others. Mary Stephenson of Hertford County proudly displays a stick of cured, graded, and tied tobacco that was market-ready. Eastern North Carolina tobacco farmers took great pride in the physical appearance of their finished product: tied, cured, and graded tobacco. This appearance prompted tobacco company buyers to pay a slightly higher price. (Courtesy of Frank Stephenson.)

The small building in the background of this image was one of three different buildings that served as tobacco pack houses on the Frank Stephenson farm in Hertford County. The stick of cured, graded, and tied tobacco displayed by Frank Stephenson Jr. was touched by a number of hands in the long tobacco harvesting process prior to becoming market-ready. (Courtesy of Frank Stephenson.)

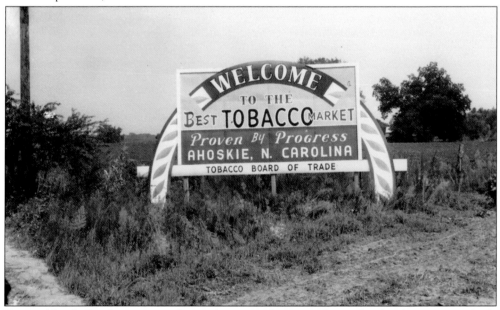

Eastern North Carolina towns where tobacco markets were located utilized various methods to promote the possibilities of high prices for individual tobacco markets. Such methods included this sign, which touted the eastern tobacco belt market in Ahoskie. (Courtesy of Frank Stephenson.)

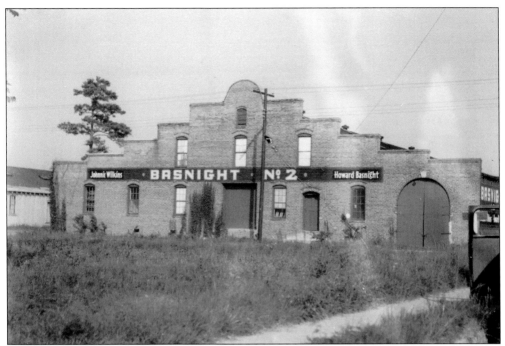

W.H. Basnight of Ahoskie operated several tobacco warehouses in Ahoskie for many years, including this brick one. Later, Basnight, Lyman Wilkins, and Harold Veasey operated a large, red, frame tobacco warehouse on Main Street in Ahoskie for a number of years. (Courtesy of Frank Stephenson.)

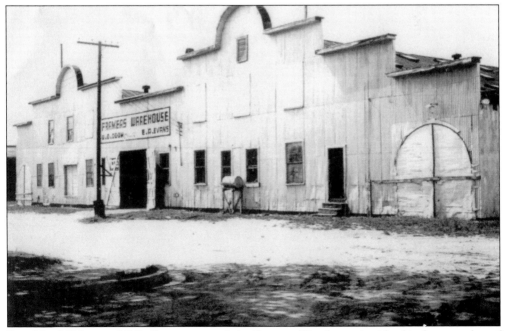

Burr Head Odum and E.R. Evans operated the Farmers Warehouse in Ahoskie for a number of years. (Courtesy of Frank Stephenson.)

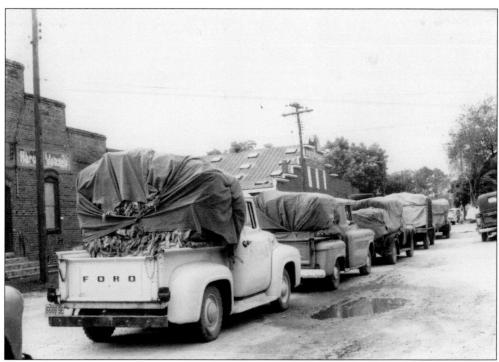

Tobacco sale days in the eastern North Carolina tobacco market towns were huge events, as tobacco farmers brought their finished product to town hoping to receive big checks to take home. Some of those who immediately benefited from the tobacco sale money were the local merchants, as many tobacco farmers would cash their tobacco checks and spend some of the money in town prior to going home. (Courtesy of Frank Stephenson.)

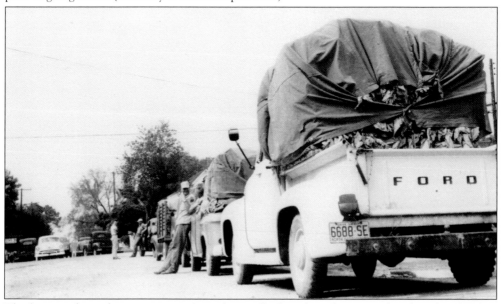

The long road in tobacco growing, from the seedbed to the tobacco market, has drawn to an end, as these tobacco farmers are waiting in line to unload their cured, graded, and tied tobacco at the tobacco market. (Courtesy of Frank Stephenson.)

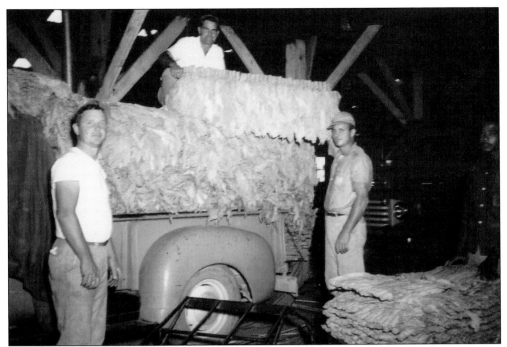

The long wait is finally over for this tobacco farmer and his crew, who have made it inside the tobacco warehouse, where they are unloading their cured and graded tobacco for weighing and sale. (Courtesy of Frank Stephenson.)

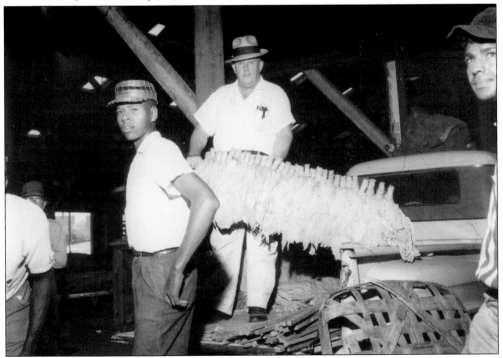

The time is here for this tobacco farmer and his crew, who unload their finished tobacco product for weighing and selling. (Courtesy of Frank Stephenson.)

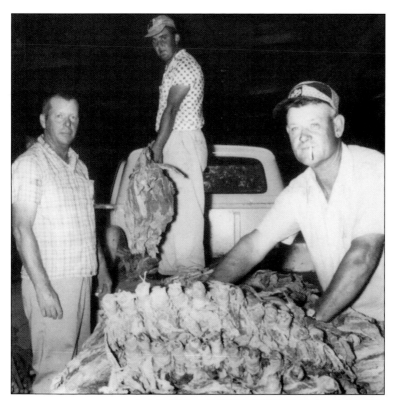

This tobacco farmer is unloading his cured, graded, and tied tobacco for sale at the tobacco market in Ahoskie. (Courtesy of Frank Stephenson.)

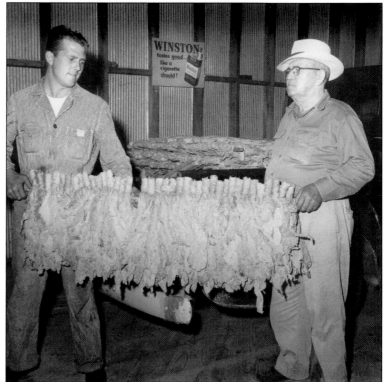

Calvin Pearce and his father, Cape Charles Pearce, of Hertford County proudly display a stick of their cured, graded, and tied tobacco as they unload at the tobacco warehouse. (Courtesy of Frank Stephenson.)

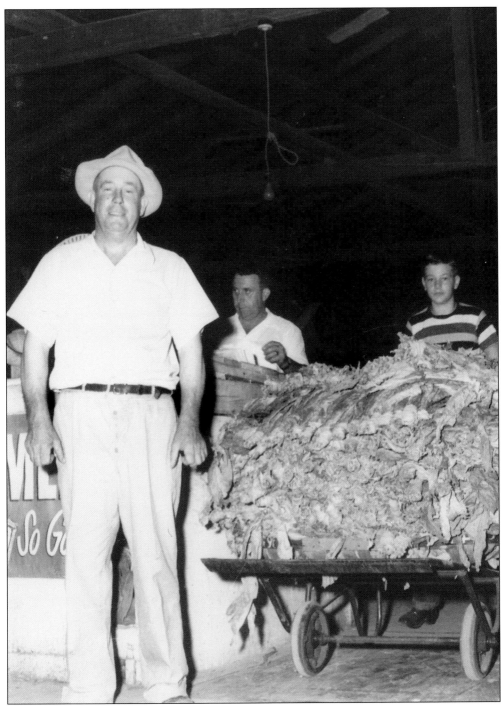

With a huge smile on his face, this proud tobacco farmer and his crew push a load of their tobacco crop toward the scales for weighing at the tobacco market. (Courtesy of Frank Stephenson.)

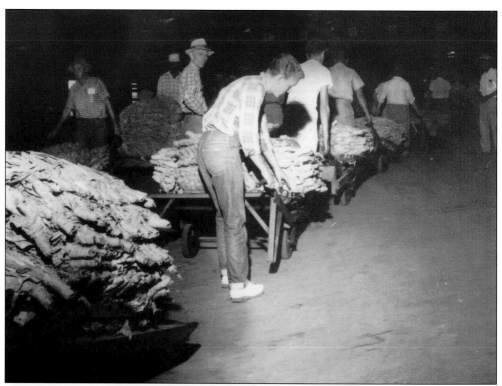

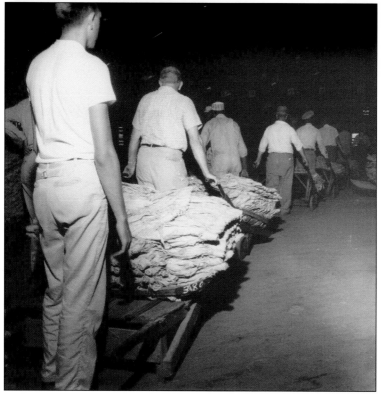

The final hour has arrived for these tobacco farmers, who are waiting in line to have their tobacco weighed and tagged for sale. (Courtesy of Frank Stephenson.)

At times, it seemed as if the line to the tobacco scales at the tobacco warehouse never moved. (Courtesy of Frank Stephenson.)

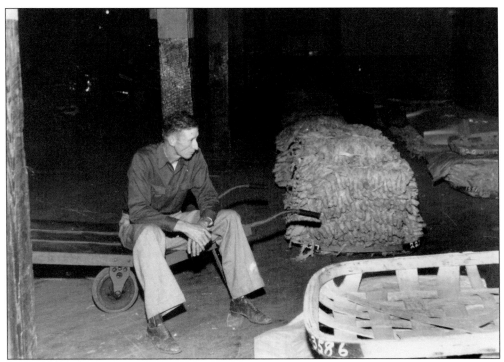

Once a tobacco farmer's load of tobacco was weighed and tagged for sale at the tobacco warehouse, the long wait until sale time began. (Courtesy of Frank Stephenson.)

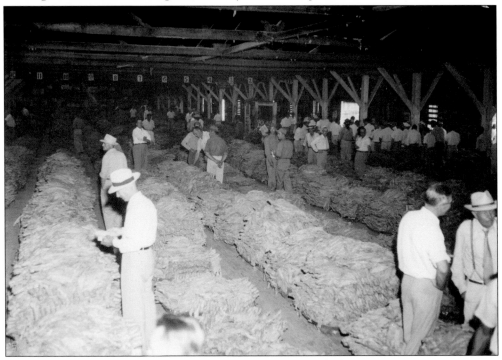

Prior to the tobacco auction, tobacco warehouse personnel and tobacco company representatives checked over the countless piles of tobacco waiting to be sold. (Courtesy of Frank Stephenson.)

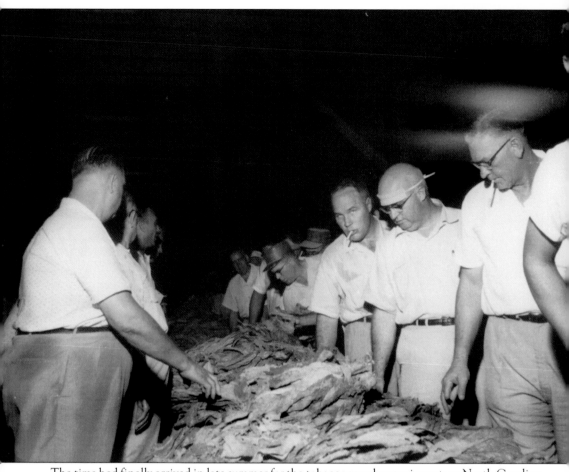

The time had finally arrived in late summer for the tobacco warehouses in eastern North Carolina to resonate with the sounds of tobacco auctioneers. (Courtesy of Frank Stephenson.)

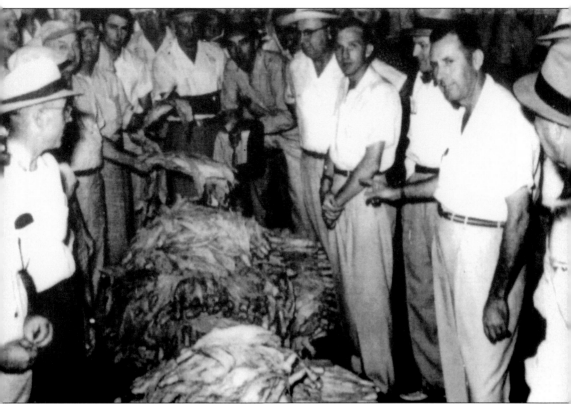

Harold Veasey, second from the right and one of the longtime owners of the big, red tobacco warehouse in Ahoskie, is shown addressing a large number of tobacco company buyers prior to the start of the tobacco auction sale. (Courtesy of Frank Stephenson.)

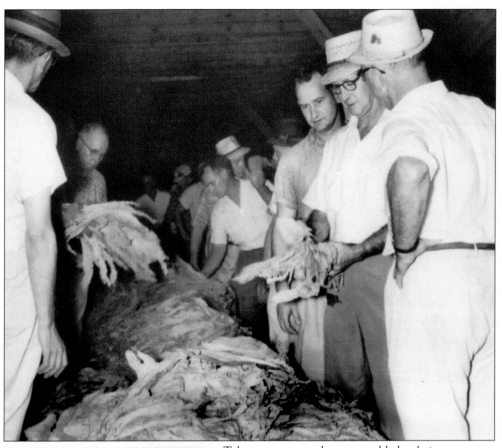

Tobacco company buyers would closely inspect the piles of cured and graded tobacco about to be sold. (Courtesy of Frank Stephenson.)

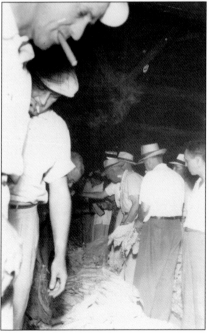

As flammable as cured and graded tobacco was, it would seem that smoking in the tobacco warehouses could have been disastrous. (Courtesy of Frank Stephenson.)

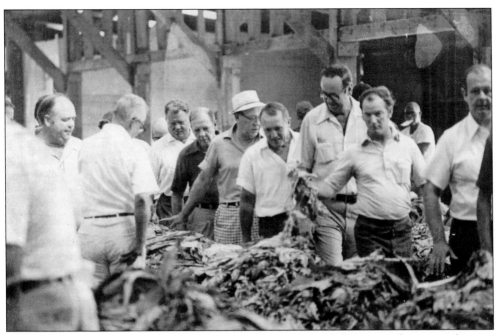

The tobacco auctioneer was often the most popular person in a tobacco warehouse at sale time. (Courtesy of Frank Stephenson.)

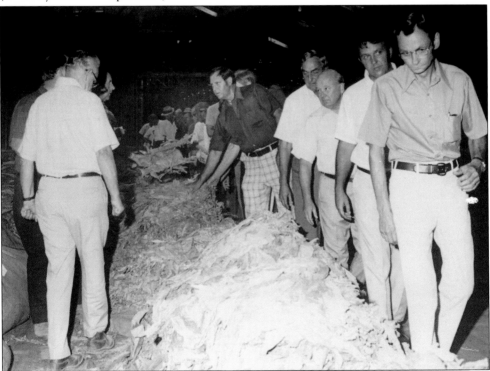

The auctioneer's chant was often hard to understand, except when he would yell out, "Sold American," which was a reference to a pile of tobacco being bought by a representative of the American Tobacco Company. (Courtesy of Frank Stephenson.)

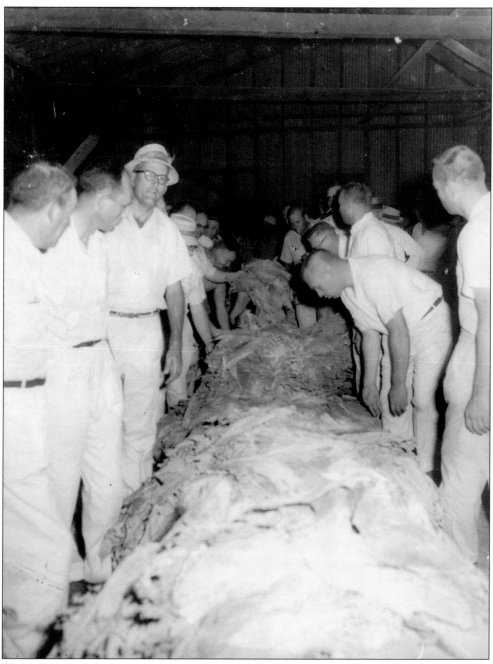

The busiest place in an eastern North Carolina tobacco warehouse at tobacco sale time was the tobacco auctioneer's line. (Courtesy of Frank Stephenson.)

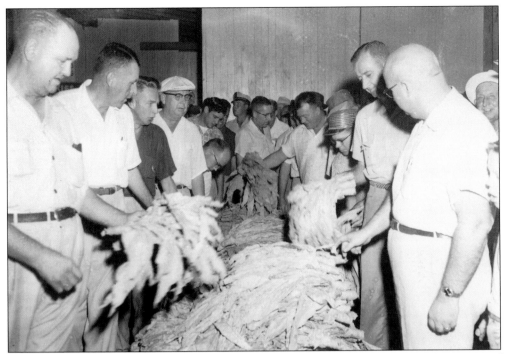

While the men who served as tobacco auctioneers changed through the years, the process of tobacco auctioneering remained virtually unchanged. (Courtesy of Frank Stephenson.)

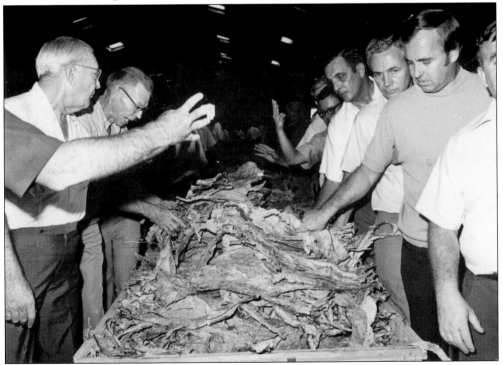

"Going once, going twice, going three times—sold to" was the final chant of the tobacco auctioneer. (Courtesy of Frank Stephenson.)

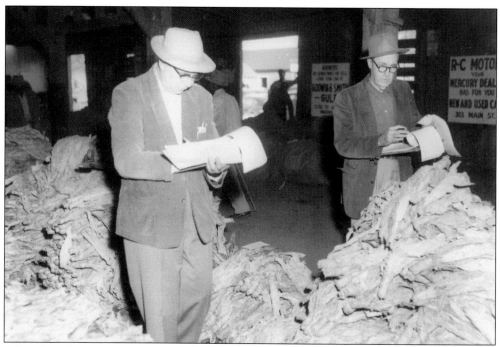

After the tobacco auctioneer and the line of tobacco company buyers had passed, tobacco warehouse representatives followed closely to record the tobacco sale numbers. (Courtesy of Frank Stephenson.)

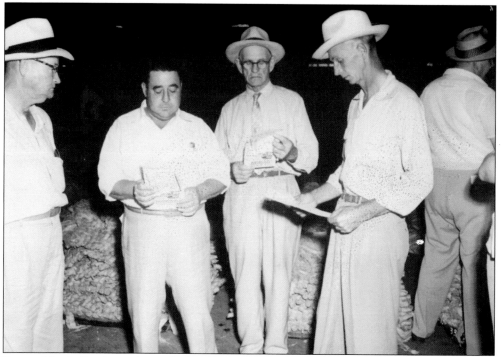

Eastern North Carolina tobacco farmers checked their tally sheets from the sale of their tobacco. (Courtesy of Frank Stephenson.)

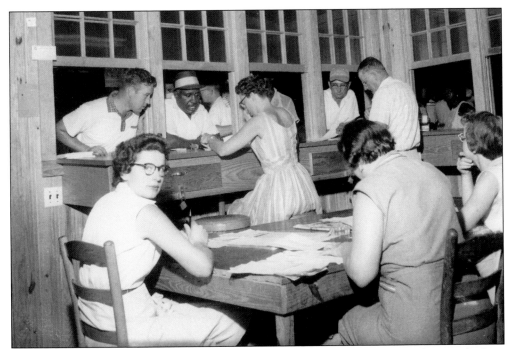

The payoff office was the most popular place in the tobacco warehouse on tobacco sale days, as the individual tobacco sale tickets were tallied and the checks were written. (Courtesy of Frank Stephenson.)

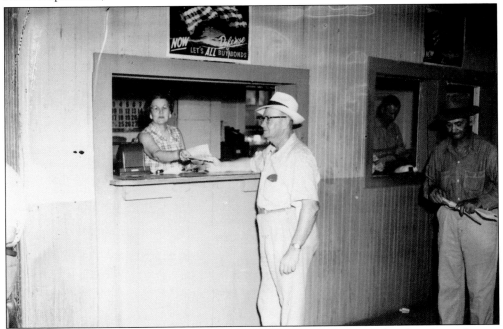

At last, the moment was at hand when the tobacco sales check was handed to the tobacco farmer. The money from the sale of tobacco came at a good time for eastern North Carolina tobacco farm families, usually in late summer or early fall, as their other crops, such as peanuts, corn, and cotton, did not pay off until later in the fall. (Courtesy of Frank Stephenson.)

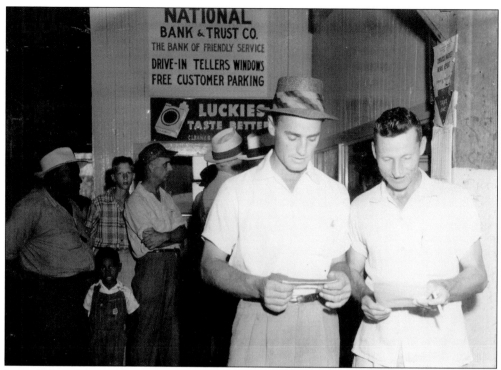

James Baker (left) and James Brown of Hertford County appear to be pleased with the tobacco checks handed to them at the payoff window in the big, red tobacco warehouse in Ahoskie. (Courtesy of Frank Stephenson.)

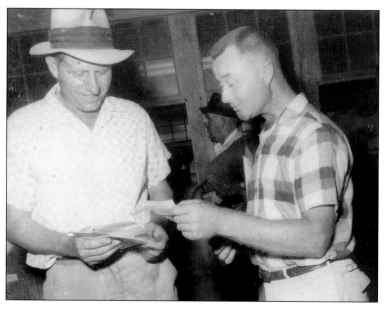

Another duo of tobacco farmers also appear to be quite pleased with their tobacco checks at payoff time. Eastern North Carolina tobacco farmers were very good at bringing in excellent tobacco crops, and they were rewarded with good prices for their labors. (Courtesy of Frank Stephenson.)

Two

PEANUT FIELDS FOREVER

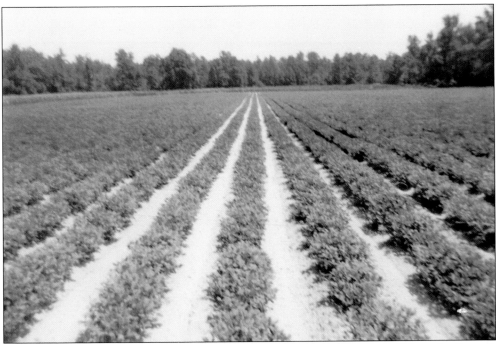

The peanut plant is South American in origin, likely from Peru or Brazil. When the Spanish began exploring the New World, they found peanuts being grown as far north as Mexico. Spanish explorers took peanuts back to Spain, where Spanish explorers and traders took them to parts of Asia and Africa. When slaves from Africa were brought to America, peanuts were brought with them, which led to peanuts being planted in the southern United States. At first, peanuts were slow to catch on, because the growing and harvesting of them was a slow and laborious task until equipment for planting, cultivating, harvesting, and picking peanuts were introduced early in the 19th century. Research by George Washington Carver ultimately led to the increase in demand for roasted and salted peanuts, peanut butter, and peanut candy. The increased demand for peanuts and peanut-related products gave rise to huge crops of peanuts being grown in eastern North Carolina. This photograph was taken in 1955. (Photograph by Frank Stephenson.)

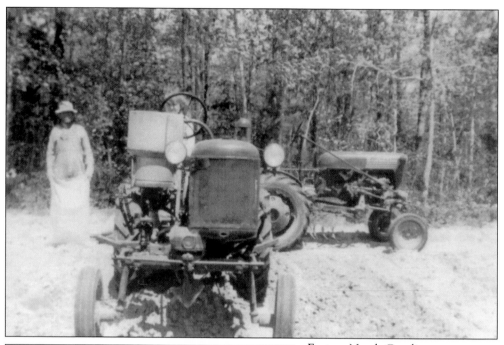

Eastern North Carolina peanut farmer Ross Nichols and his daughter Delores are seen planting peanuts on their farm in the Earlys Station area of Hertford County. (Courtesy of Barbara Nichols Mulder.)

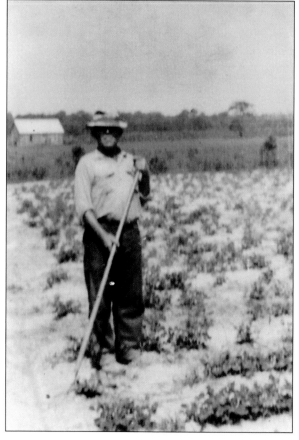

Eastern North Carolina peanut farmers and their families spent many long hours chopping weeds and grass out of their peanut fields. (Courtesy of Barbara Nichols Mulder.)

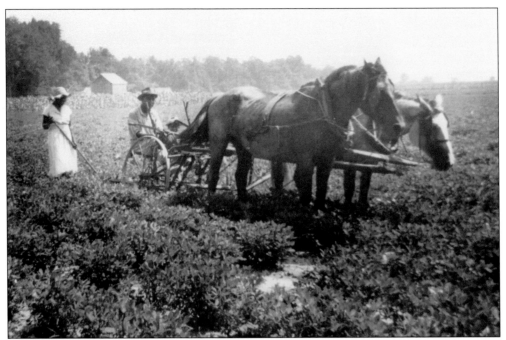

This Hertford County peanut farmer and his wife are in the process of "laying by" their field of peanuts in this 1940s photograph. (Courtesy of Frank Stephenson.)

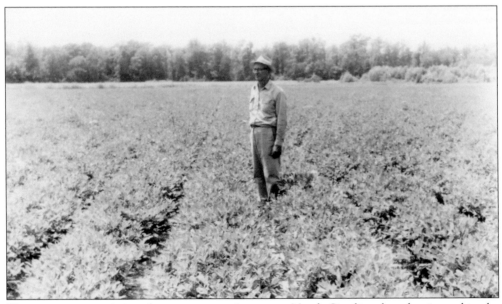

There were two varieties of peanuts grown in eastern North Carolina: bunch, pictured in the previous photograph, and runners, seen here. (Courtesy of Frank Stephenson.)

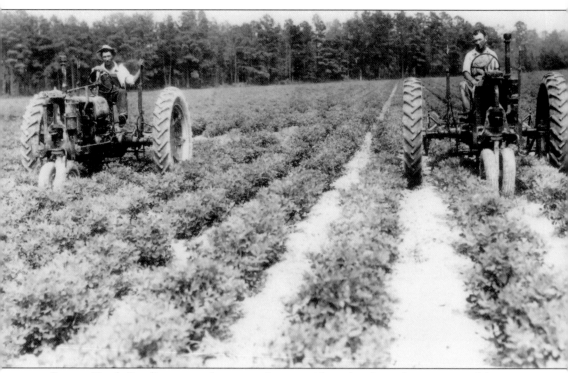

Eastern North Carolina peanut farmers took great pride in the physical appearance of their peanut fields. These peanut farmers are seen cultivating their peanut crop to prevent grass and weeds from taking over, as that would be a hindrance at harvest time. (Courtesy of Frank Stephenson.)

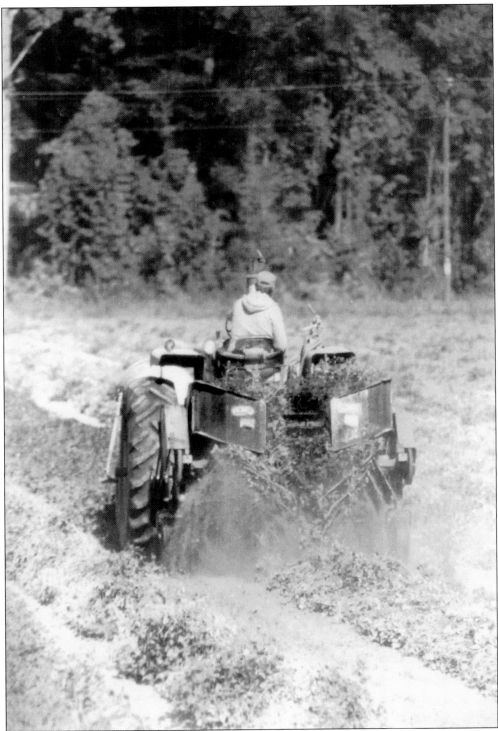

The harvesting of peanuts began with the digging up of the peanut plants, or vines, bearing the raw peanuts. This peanut farmer is utilizing a one-row peanut digger to dig and turn up his peanut crop so that the raw peanuts could air-dry prior to harvesting. (Courtesy of Frank Stephenson.)

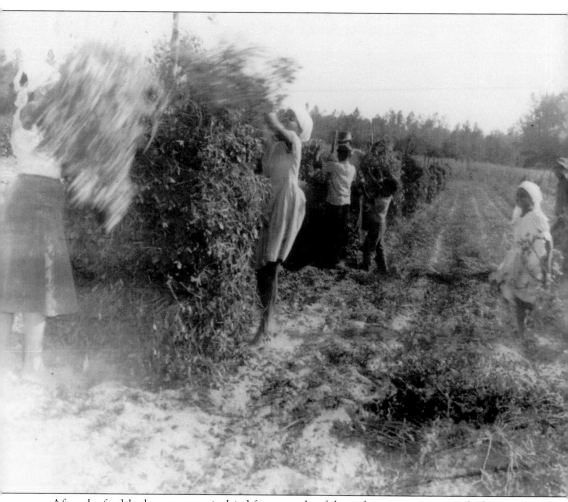

After the freshly dug peanuts air-dried for a couple of days, the peanut vines with the attached raw peanuts were shook out and stacked on peanut poles for air-drying prior to harvesting with a peanut picker. Since the shaking and stacking of freshly dug peanuts was labor-intensive, many family members were involved in the process. (Courtesy of Frank Stephenson.)

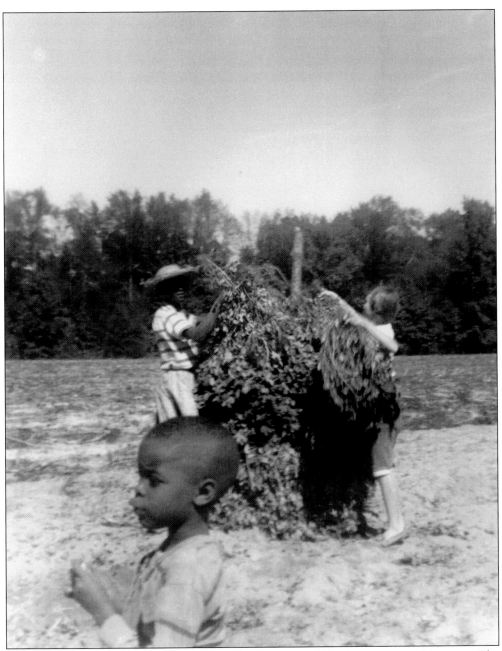

This stack of freshly dug peanuts in 1956 is being topped off by the peanut-stacking crew. The purpose of the peanut stacks was to give the raw, or green, peanuts an opportunity to cure and dry for about four or five weeks before being harvested and taken to market. (Photograph by Frank Stephenson.)

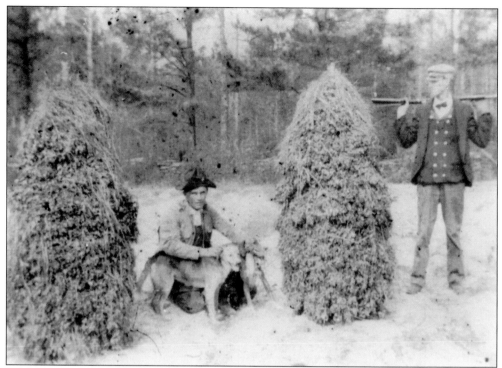

With the peanut crop stacked for drying and curing, peanut farmers were provided with an opportunity to do a little hunting and fishing prior to the final steps in the peanut growing process: harvesting and marketing. (Courtesy of Frank Stephenson.)

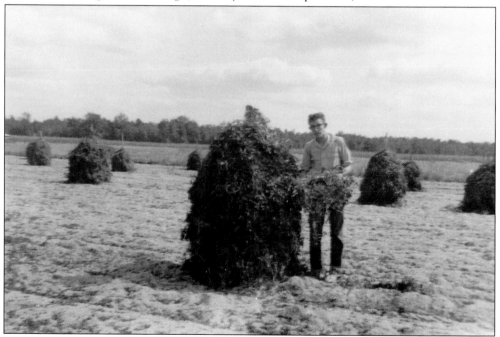

This high school farm boy proudly displays peanuts that have been dug, shaken, and stacked. (Courtesy of Frank Stephenson.)

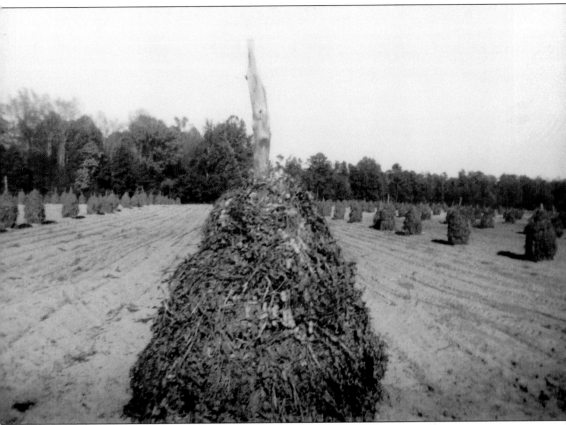

Before peanuts were mechanically harvested and dried in peanut trailers, freshly dug peanuts were stacked by hand to cure and dry, as seen here in 1954. There was somewhat of an art to stacking peanuts, as they had to be stacked in just the right way so that the stack could shed rainwater, preventing the peanuts from rotting. (Photograph by Frank Stephenson.)

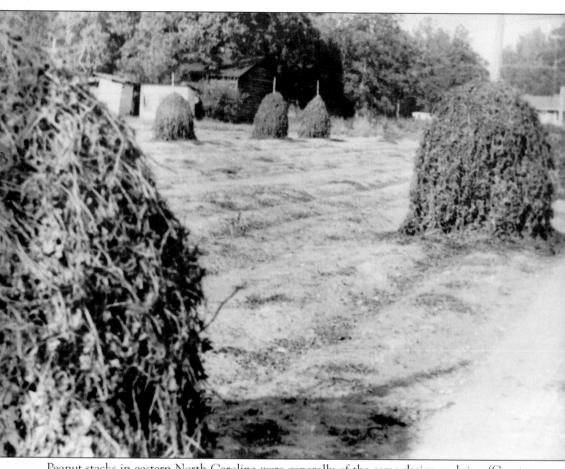

Peanut stacks in eastern North Carolina were generally of the same design and size. (Courtesy of Frank Stephenson.)

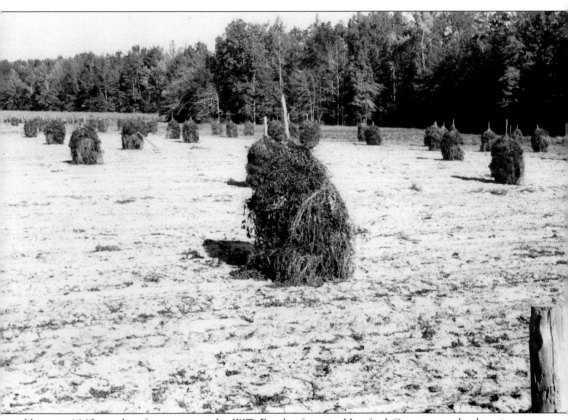

Here, in 1960, stacks of peanuts on the W.T. Bowles farm in Hertford County are slowly going through the drying and curing process prior to harvesting. (Photograph by Frank Stephenson.)

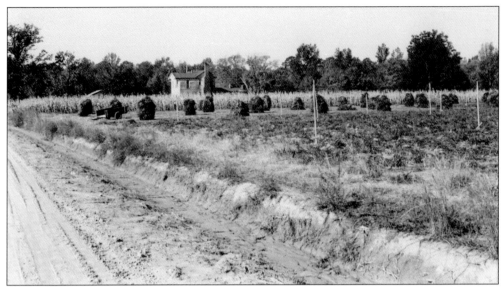

This 1957 scene was repeated many times over in eastern North Carolina during the peanut harvesting season. (Photograph by Frank Stephenson.)

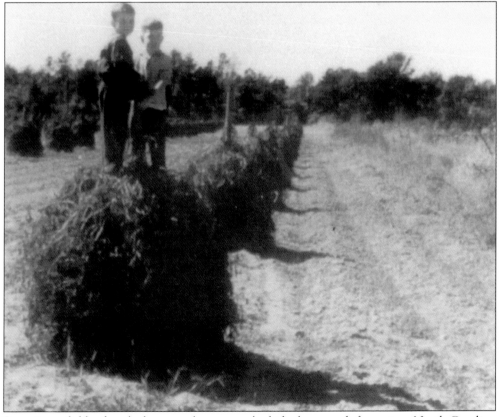

Sometimes, fields of stacked peanuts became makeshift playgrounds for eastern North Carolina farm children, as seen in this 1970s photograph of cousins Darhyl and Billy Vann of Murfreesboro. (Courtesy of Don Vann.)

The twilight of the day closes in on a field of stacked peanuts in eastern North Carolina as the time was drawing near for peanut farmers to harvest and market their peanut crops. (Courtesy of Frank Stephenson.)

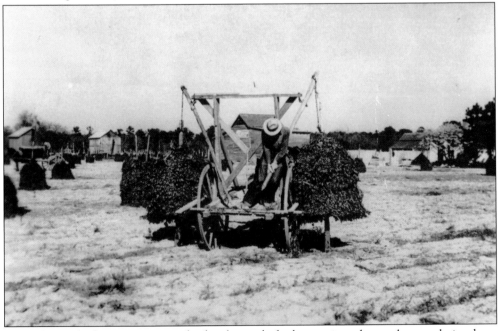

After the stacked peanuts were judged to be ready for harvesting, the stacks were hoisted out of the ground by a swing cart and delivered to the peanut picker for harvesting. (Courtesy of Frank Stephenson.)

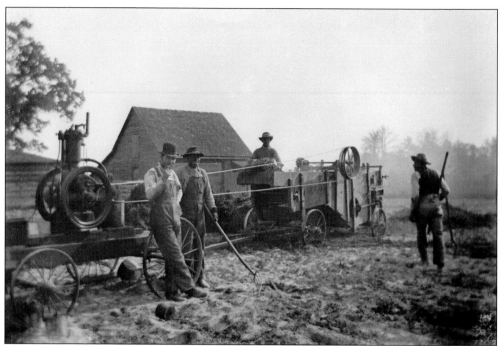

This photograph from around 1910 provides a view of an early peanut picker, which was used to separate the peanuts from the peanut vines. Prior to the development of this type of peanut picker, or harvester, peanuts were picked off the peanut vines by hand. (Courtesy of Frank Stephenson.)

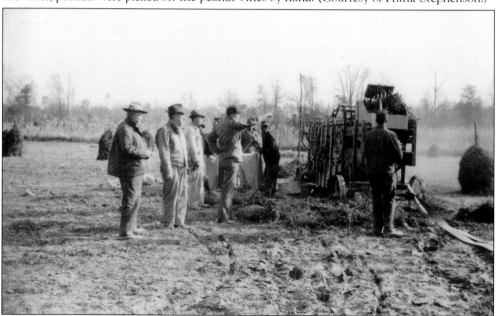

Harvesting, or picking, peanuts was a labor-intensive process, and a number of men were required to operate and support the peanut picker. One of the problems frequently encountered during this process was the main power belt from the tractor to the peanut picker coming off one of the pulleys. Some peanut farmers poured molasses on the belts to prevent them from coming off. (Courtesy of Frank Stephenson.)

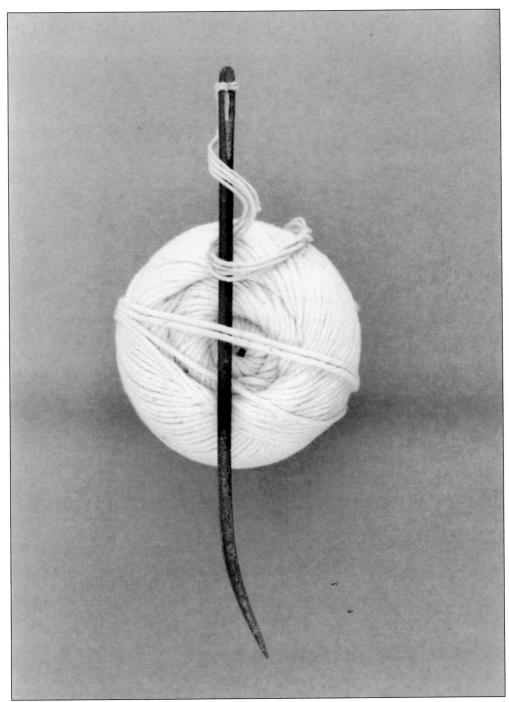

This 1955 photograph shows a ball of peanut twine and a peanut needle, which were used to sew up, or close, the bags of peanuts that came from the peanut picker. (Photograph by Frank Stephenson.)

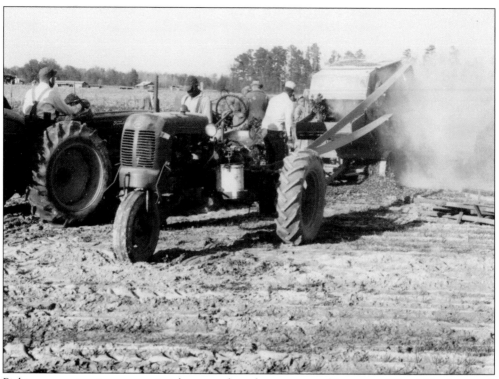

Picking peanuts using a peanut picker was a hot, dusty process. (Courtesy of Frank Stephenson.)

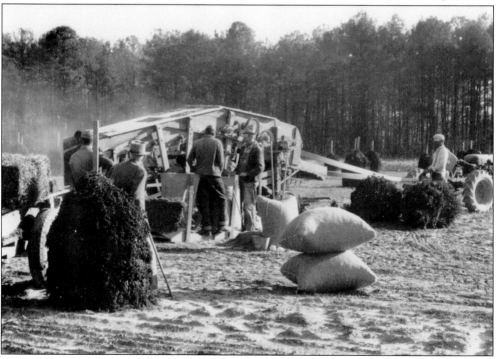

This 1957 photograph provides an excellent view of the operation of the peanut picker, from rear to front. (Courtesy of Frank Stephenson.)

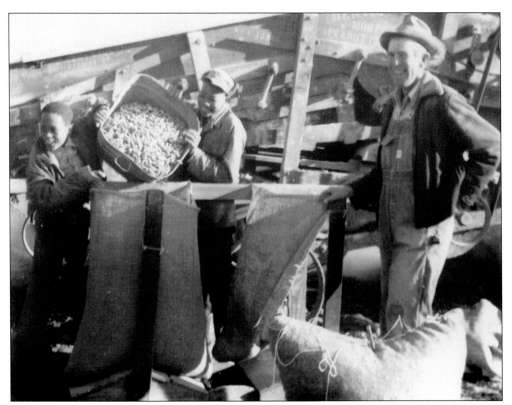

Loose peanuts coming out of the peanut picker were poured in peanut sacks, or bags, for sewing up and transporting to the peanut market. If the peanut bags were not sewn up properly, the peanuts would fall out. (Courtesy of Frank Stephenson.)

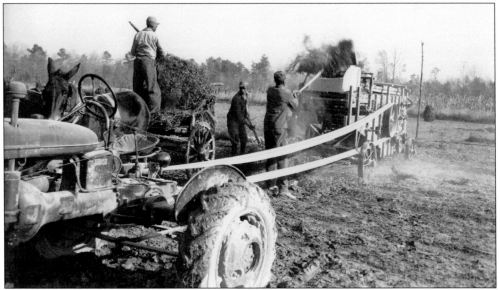

Stacks of cured and dried peanuts are brought to the front of the peanut picker, where the peanut pole is removed and the peanut-laden vines are fed into the front end of the peanut picker. (Photograph by Frank Stephenson.)

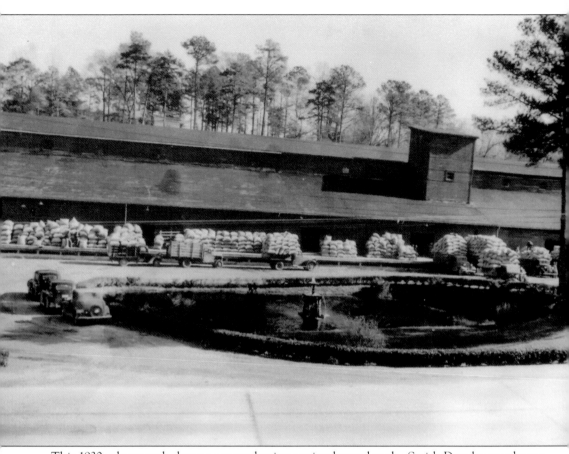

This 1930s photograph shows a peanut-buying station located at the Smith-Douglas warehouse in Murfreesboro, where freshly harvested eastern North Carolina–grown peanuts were purchased and shipped to the Planters Peanuts processing plant in Suffolk, Virginia. (Courtesy of Frank Stephenson.)

Three

Corn, Cotton, and Hosiery

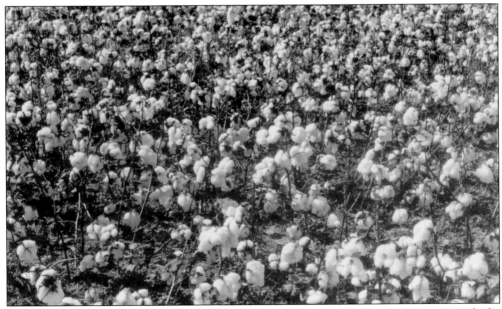

Eastern North Carolina farmers grew many different crops, including cotton, to provide for their families. A large amount of the cotton grown in eastern North Carolina was purchased by such North Carolina textile companies as Hanes, Fieldcrest, and Cannon. (Photograph by Frank Stephenson.)

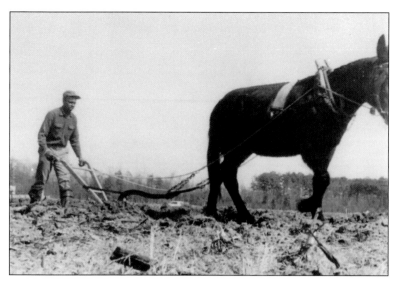

The process of breaking, or preparing, farmland for planting cotton and other crops was initially done by mule and plow, as seen in this 1950s photograph. (Courtesy of Frank Stephenson.)

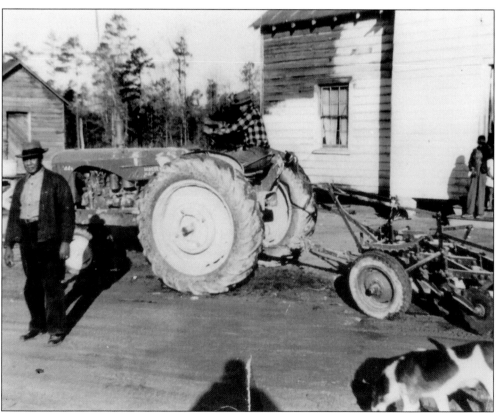

Gradually, the process of breaking land for planting crops was made a little easier with the tractor-pulled breaking plow, seen in this 1960s photograph of Dr. Jim Jordan (standing) and his grandson Raymond Whitehead. In addition to owning farms in North Carolina and Virginia, as well as logging operations, Dr. Jordan became one of the more famous conjure doctors on the East Coast. (Courtesy of Frank Stephenson.)

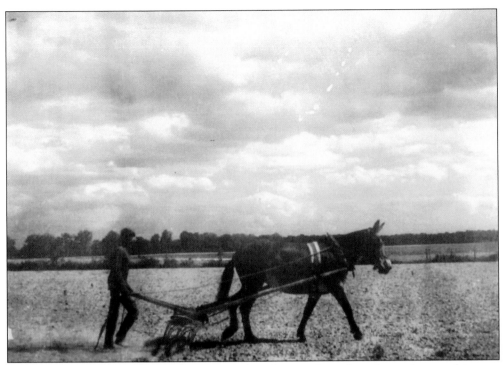

The process of cultivating fields of cotton was done for years by mule- or horse-drawn cultivators, as seen in this 1950s photograph. (Courtesy of Frank Stephenson.)

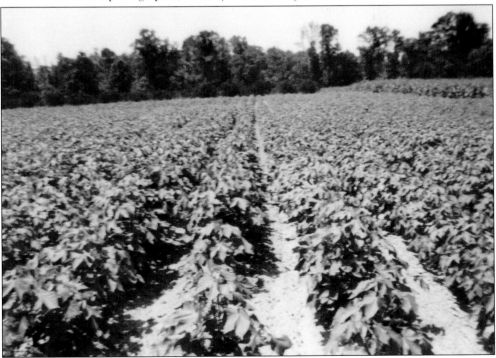

Eastern North Carolina cotton farmers were especially skilled at producing lush fields of cotton. (Photograph by Frank Stephenson.)

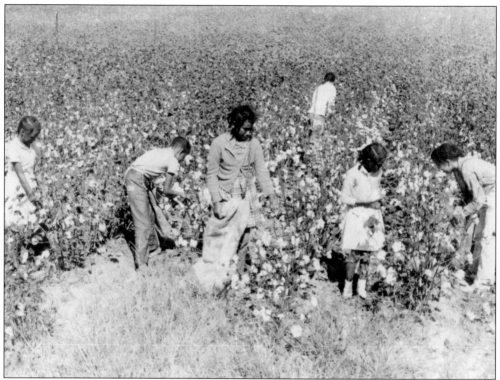

The process of harvesting, or picking, cotton was done by hand for many years, as shown in this 1955 photograph. Many hands and many long hours were needed to pick a field of cotton. If a person picked 100 pounds of cotton by hand in a day, it was judged to be a good day in the cotton fields. (Courtesy of Frank Stephenson.)

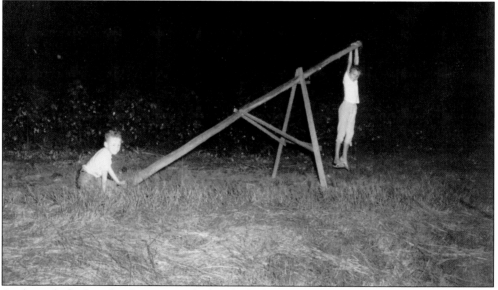

At the end of a day of picking cotton by hand, the bags of picked cotton were weighed on scales that were attached to a pylon similar to the one shown in this 1957 photograph. (Courtesy of Frank Stephenson.)

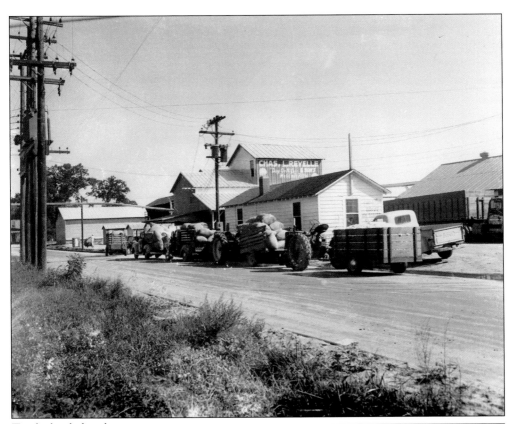

Trucks loaded with cotton are seen here waiting in line at a cotton gin. (Courtesy of Frank Stephenson.)

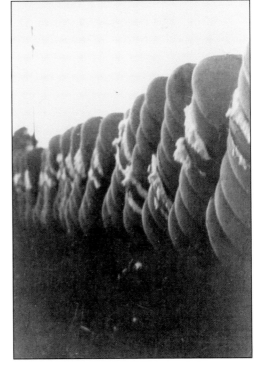

The late afternoon sun of an October day in the late 1960s shines on a row of newly ginned and baled cotton at Revelle's cotton gin in Murfreesboro. (Courtesy of Frank Stephenson.)

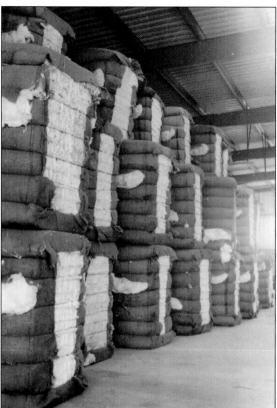

Bales of newly ginned eastern North Carolina cotton were stored in a warehouse while awaiting shipment to textile mills all over the state. (Courtesy of Frank Stephenson.)

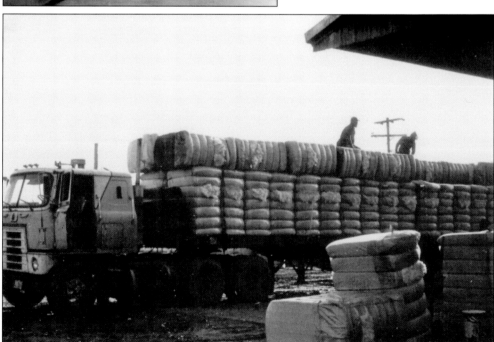

These bales of freshly ginned cotton are being loaded onto a truck for shipment to North Carolina textile mills. (Courtesy of Frank Stephenson.)

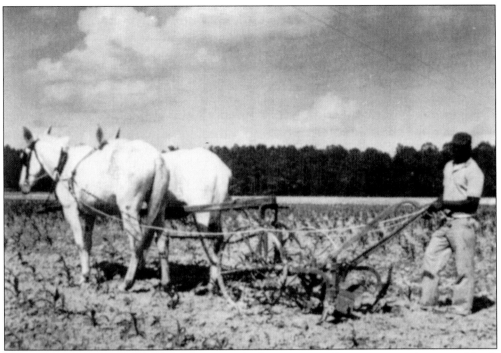

The process of plowing and cultivating corn and other row crops that were grown in eastern North Carolina has progressed significantly since the days of using a cultivator pulled by two mules, as seen in this 1950 photograph. (Courtesy of Frank Stephenson.)

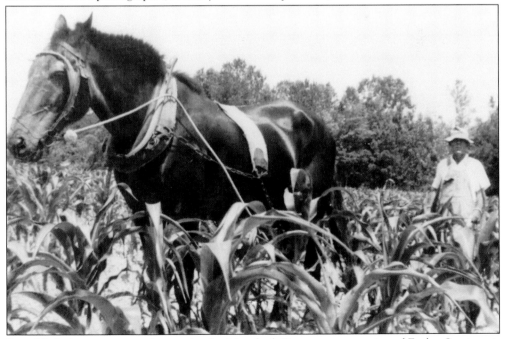

Ross Nichols, a row crop farmer in the Hertford County community of Earlys Station, is seen here plowing his cornfield with his mule Charlie in the 1950s. (Courtesy of Barbara Nichols Mulder.)

Eastern North Carolina farmers faced many different challenges in bringing their crops in each year. High winds, as seen in this 1970s photograph, were a serious threat to fields of mature tobacco and corn, as they could blow the tobacco and corn stalks over or down to such a point that it was almost impossible to harvest. (Courtesy of Frank Stephenson.)

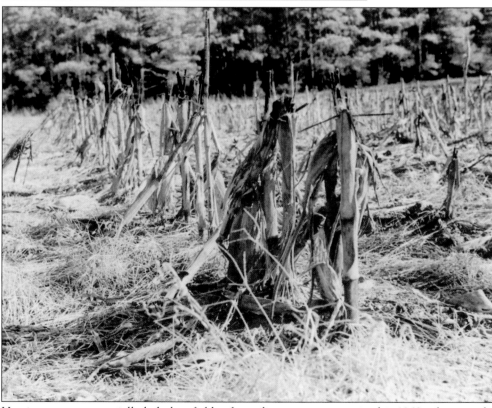

Hurricanes were especially lethal to fields of standing corn, as seen in this 1960s photograph. In this case, a field with mature corn was nearing harvest when a hurricane ripped through it. The farmer was left with the prospect of trying to salvage and harvest his corn crop by hand. (Courtesy of Frank Stephenson.)

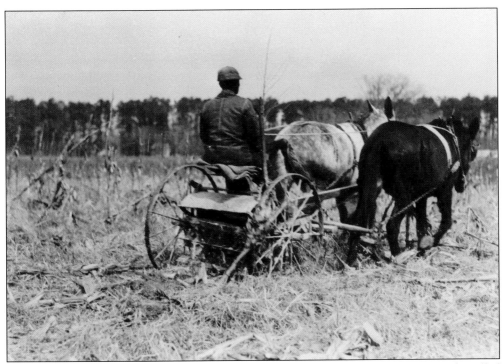

After corn and tobacco were harvested, the stalks were chopped by the one-row, mule-pulled stalk cutter seen in this 1950s photograph. (Courtesy of Frank Stephenson.)

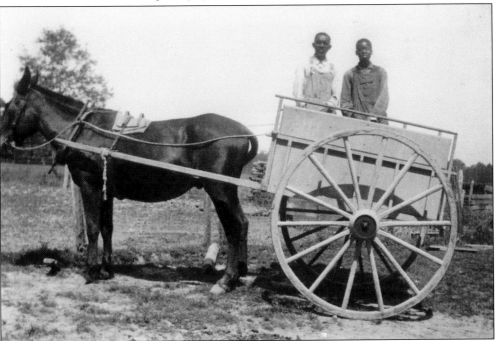

Farm life in eastern North Carolina has progressed by leaps and bounds since the mule-and-cart days. It would be a rare sight today to see a mule and a cart in eastern North Carolina. (Courtesy of Frank Stephenson.)

For many years, eastern North Carolina was dotted with corn mills or gristmills, such as Hare's Mill in Hertford County, seen here in 1957. Farmers would take some of their corn crop to a corn mill, where it would be ground into cornmeal. The miller would keep a portion of the cornmeal in exchange for his services. (Photograph by Frank Stephenson.)

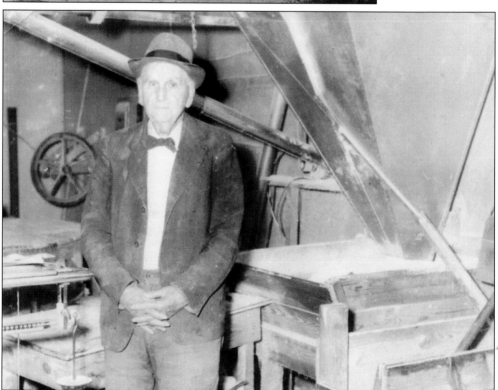

The millers who operated the local gristmills often served as community resource persons, through whom information and news could be exchanged. One such miller was E.C. Worrell, who operated Worrell's Mill on the outskirts of Murfreesboro for many years. (Courtesy of Frank Stephenson.)

Four

PICKLES, MOLASSES, AND POTATOES

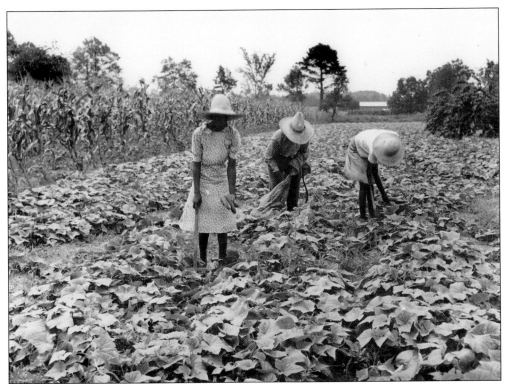

In addition to growing tobacco, peanuts, cotton, and corn, eastern North Carolina farmers also grew other cash crops such as cucumbers, watermelons, and potatoes. These three individuals are picking cucumbers in Hertford County in the 1930s. (Courtesy of Frank Stephenson.)

Harvesting cucumbers was a long, slow, and backbreaking process over a period of weeks during the cucumber growing season. The smallest cucumber would bring the highest price for the cucumber farmer at the cucumber-buying station. Since cucumbers would grow rapidly in the hot summer sun, cucumber farmers would be in the cucumber fields at daybreak to pick the smaller ones. (Courtesy of Frank Stephenson.)

This 1930s photograph of a large field of cucumbers in eastern North Carolina presented a formable task for the cucumber pickers who were responsible for harvesting the cucumbers. (Courtesy of Frank Stephenson.)

Cucumber-buying stations, like the one seen here in Murfreesboro in the 1930s, were scattered across eastern North Carolina. Cucumber farmers would take their harvested cucumbers to the buying station, where they were sorted, graded, and weighed. (Courtesy of Frank Stephenson.)

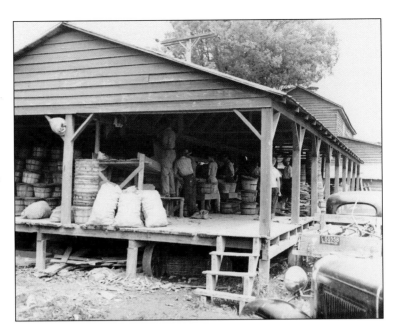

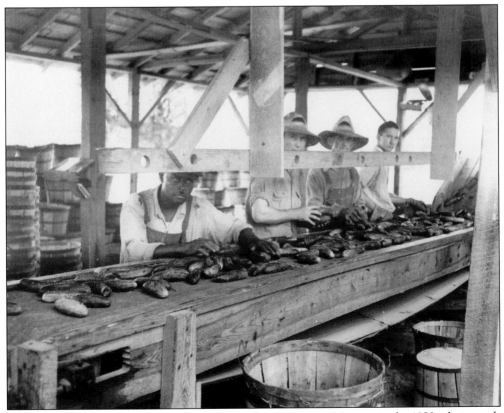

A number of people were employed at cucumber-buying stations, as seen in the 1930s photograph of Revelle's cucumber-buying station in Murfreesboro. (Courtesy of Frank Stephenson.)

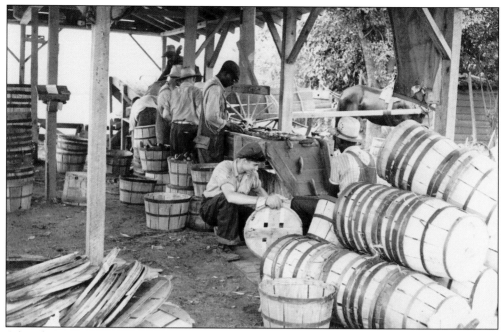

After the cucumbers were graded at the cucumber-buying station, they were placed in wooden bushel baskets for shipment to the cucumber processor. The wooden bushel baskets shown in this 1930s photograph were made at Riverside Manufacturing Company, the "world's largest basket factory," which was located in Murfreesboro. (Courtesy of Frank Stephenson.)

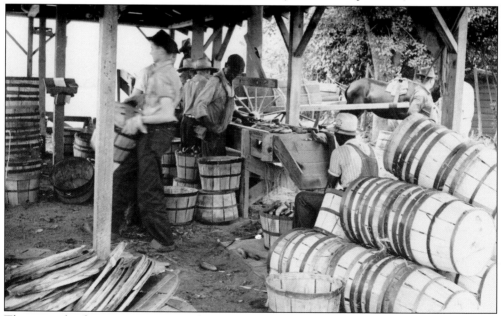

The cucumber-buying stations were busy places during the height of the cucumber growing season, as seen in this 1930s photograph. If there ever was a universal, utilitarian piece of farm equipment, it was the farm bushel basket (also known as the peach bushel basket), shown here. This simple wooden container was a mainstay on eastern North Carolina farms for many years. (Courtesy of Frank Stephenson.)

While many eastern North Carolina farmers grew sugar cane for use in producing their own supply of molasses, few of the farmers owned cane mills like the one seen here in Northampton County in the 1960s. (Courtesy of Frank Stephenson.)

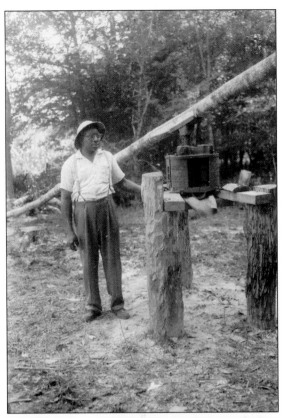

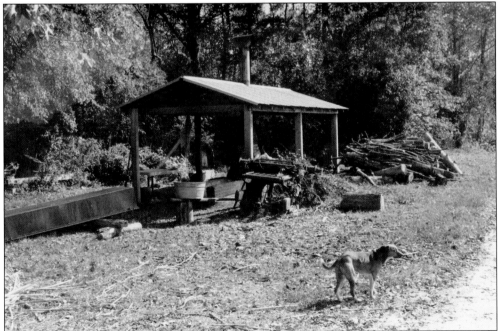

In the early 1960s, Frank Stephenson Sr. built and operated this molasses mill on his farm in Hertford County. (Photograph by Frank Stephenson.)

81

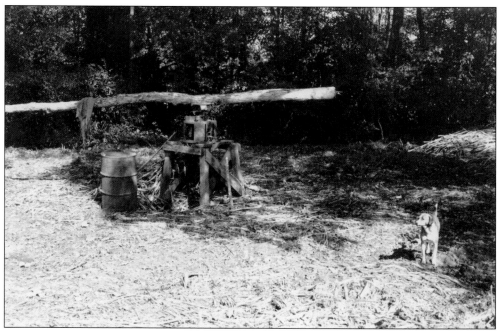

Stacks of sugar cane were run through this cane mill press at the molasses mill on the Frank Stephenson Sr. farm in Hertford County, seen here in 1962. (Photograph by Frank Stephenson.)

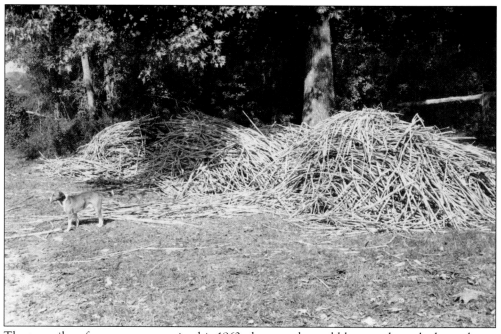

The two piles of sugar cane seen in this 1962 photograph would be run through the molasses mill to squeeze the syrup from them. The syrup was then cooked down to a heavy, thick, brown liquid that became molasses. (Photograph by Frank Stephenson.)

This is a full view of the molasses mill on the Frank Stephenson Sr. farm in Hertford County in 1962. (Photograph by Frank Stephenson.)

The fuel used to cook molasses at the molasses mill on the Frank Stephenson Sr. farm was wood, as shown here in 1962. (Photograph by Frank Stephenson.)

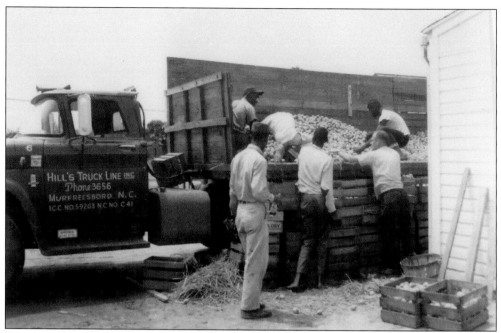

Eastern North Carolina farmers grew many different crops to provide for their families, including Irish, or white, potatoes, as seen in this 1960 photograph. (Courtesy of Frank Stephenson.)

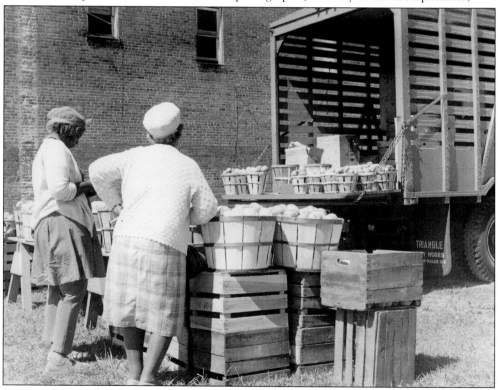

Farm produce markets located across eastern North Carolina provided an excellent opportunity for farmers to sell their Irish potatoes. (Courtesy of Frank Stephenson.)

Five

COUNTRY HAM, CHITLINS, AND SAUSAGE

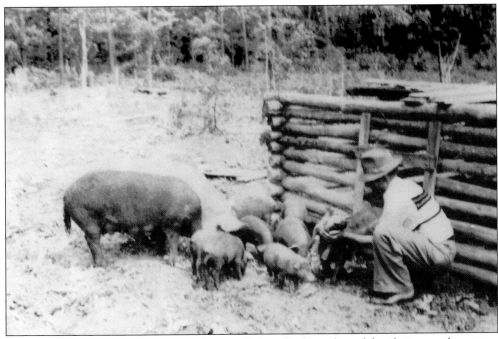

Eastern North Carolina farmers supplemented their food supply and family income by raising hogs, as seen in this early-1940s photograph of Hertford County farmer Ross Nichols with a mama sow and her pigs. The homegrown hogs that were not used for family consumption were sold at nearby Smithfield (Virginia) Packing Company hog-buying stations, which were scattered across eastern North Carolina. (Courtesy of Barbara Nichols Mulder.)

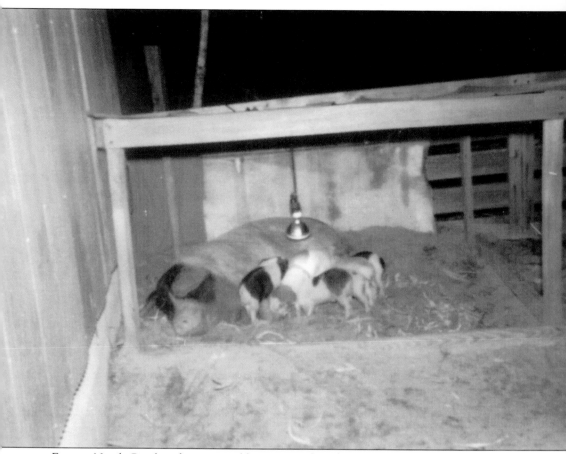

Eastern North Carolina farmers would go to great lengths to protect their newborn pigs, as seen in this 1955 photograph of a heat lamp being utilized to provide heat on a cold night. (Photograph by Frank Stephenson.)

In early January, hog gallows were usually erected in preparation for killing hogs during the cold weather, which was necessary to prevent the freshly slaughtered pork from spoiling. This 1957 photograph shows the hog gallows on the Frank Stephenson Sr. farm in Hertford County. (Photograph by Frank Stephenson.)

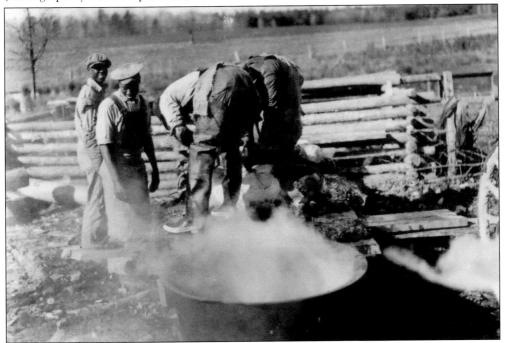

After the individual hogs were slaughtered, they were dipped in scalding hot water in order to remove the hair from their bodies, as seen in this 1930s photograph on the Eugene Stephenson farm in Hertford County. (Courtesy of Frank Stephenson.)

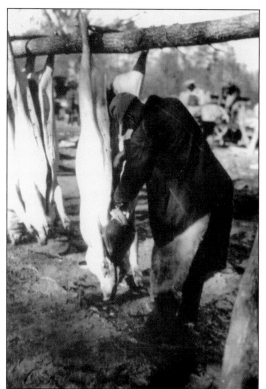

After the hogs had been scalded and scraped, they were hung on the hog gallows, where their intestines and internal organs were removed, as seen in this 1930s photograph. The hog livers were often cooked on the same day they were removed from the hogs, as fresh liver with onion gravy was a favorite Southern dish. (Courtesy of Frank Stephenson.)

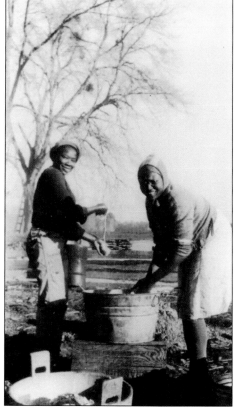

The removed intestines were cleaned, boiled, and scrapped, as seen in this 1930s photograph on the Eugene Stephenson farm in Hertford County. The cleaned intestines were used for link sausage casings and cooked as chitlins. (Courtesy of Frank Stephenson.)

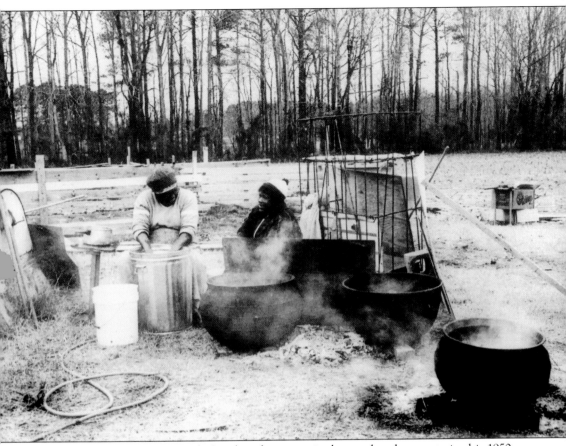

Hog-killing time on eastern North Carolina farms required many hands, as seen in this 1950s photograph of women cleaning chitlins and cooking small pieces of pork that were pressed into cracklings, producing lard. Lard was used for many years as a substitute for cooking oil. (Courtesy of Frank Stephenson.)

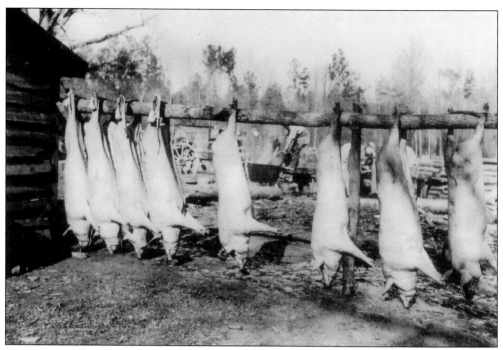

Many eastern North Carolina farmers would slaughter a number of hogs at the same time, as seen in this 1930s photograph of hog-killing time in Northampton County. (Courtesy of Frank Stephenson.)

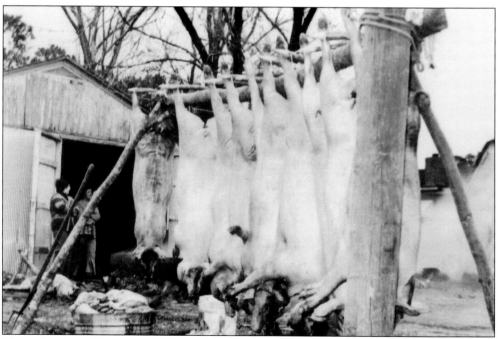

These slaughtered hogs were hung to drain out prior to the cutting-out process. (Courtesy of Frank Stephenson.)

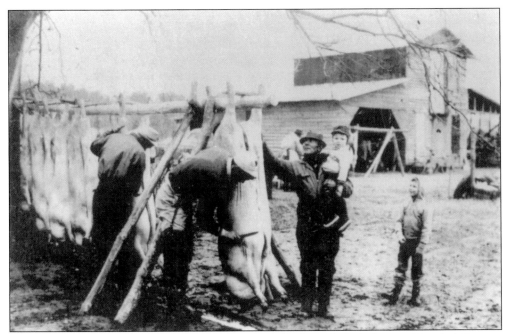

These hogs have been slaughtered and hung up on the Ross Nichols farm in Hertford County. Members of the hog-killing crew are seen scrapping down the hogs as Ross Nichols and his grandson Randy Nichols watch in this 1960s photograph. (Courtesy of Barbara Nichols Mulder.)

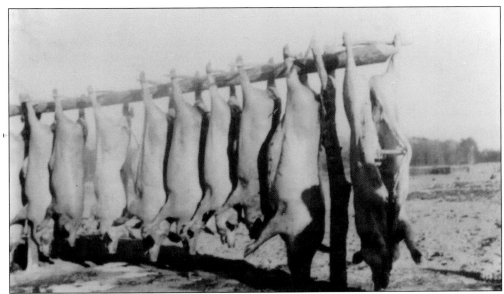

With the hard work of slaughtering and cleaning the hogs done, the next step in the hog-killing process was to let the slaughtered hogs cool off overnight before beginning the cutting-out process. (Courtesy of Frank Stephenson.)

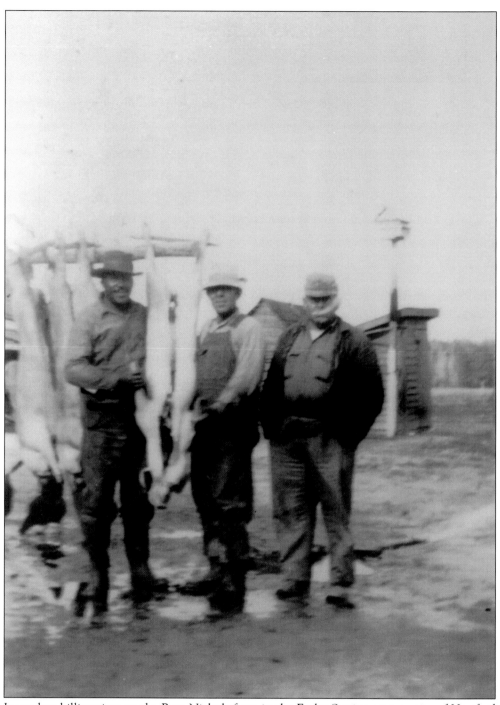

It was hog-killing time on the Ross Nichols farm in the Earlys Station community of Hertford County in the mid-1950s. From left to right are Bradshaw Early, Ross Nichols, and Paul Lee Nichols. (Courtesy of Barbara Nichols Mulder.)

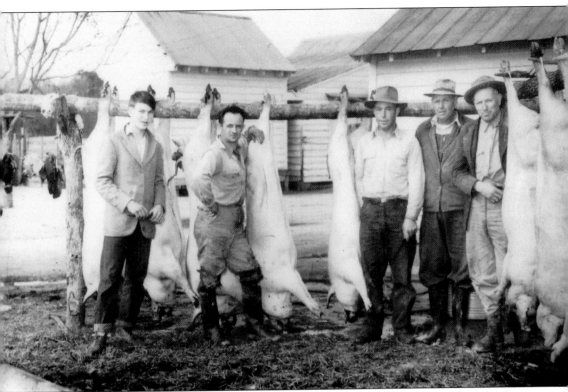

This Hertford County hog-killing crew stands with their rack of freshly slaughtered hogs in the 1950s. (Courtesy of Frank Stephenson.)

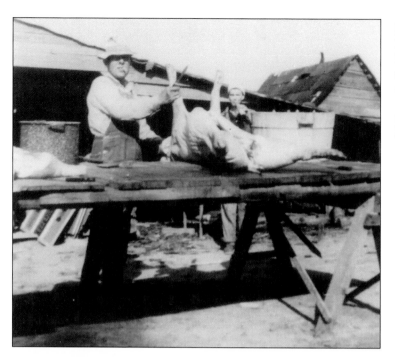

Ross Nichols and his sister-in-law Lucille B. Nichols are seen cutting out the hogs in this 1950s photograph. (Courtesy of Barbara Nichols Mulder.)

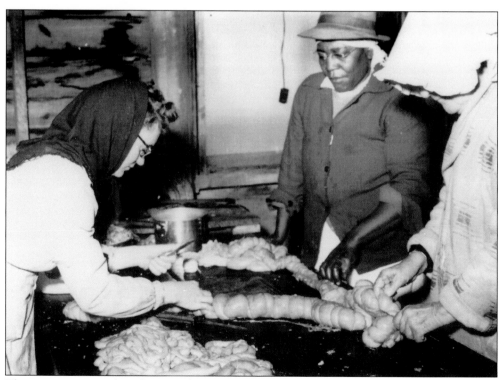

These women are making homemade sausage using chitlins for the sausage casing in the 1950s. The art of making delicious homemade link or bulk sausage required the right blend of herbs and spices. (Courtesy of Frank Stephenson.)

Six

FRIED CHICKEN, COLLARDS, AND SALT HERRING

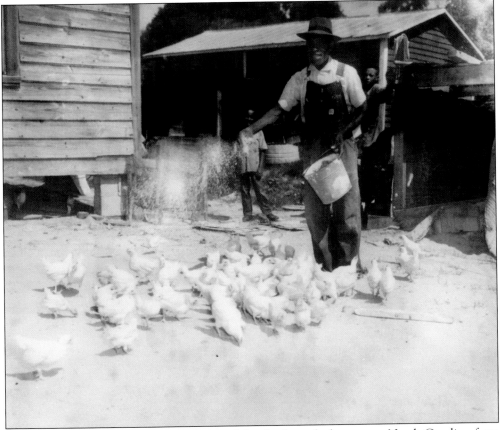

A flock of chickens was an integral part of the food supply for eastern North Carolina farm families, as seen in this 1950s Bertie County photograph. The chickens provided fresh eggs, as well as meat for fried chicken, chicken salad, chicken pot pies, barbecue chicken, chicken soup, and many other delicious dishes. (Courtesy of Frank Stephenson.)

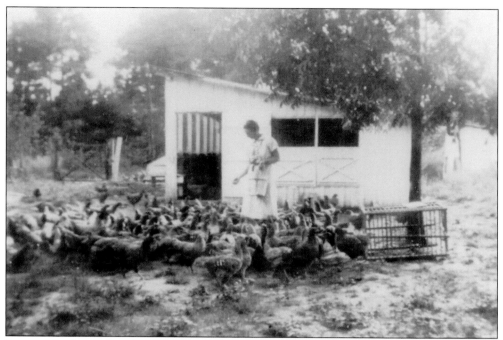

Eastern North Carolina farm families could always count on having something to eat when they had a flock of chickens. This 1950s Hertford County photograph shows a farm homemaker feeding her flock of chickens. (Courtesy of Frank Stephenson.)

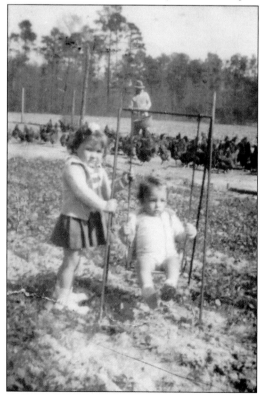

These two Hertford County children enjoy a swing in the field while another family member feeds a large flock of chickens. (Courtesy of Virgia Burkett Nichols.)

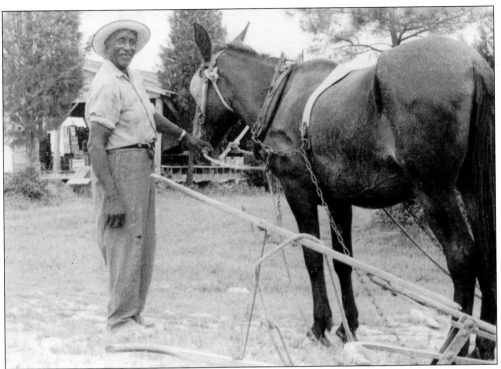

A mule and plow were essential to eastern North Carolina farm families, particularly for plowing gardens. (Courtesy of Frank Stephenson.)

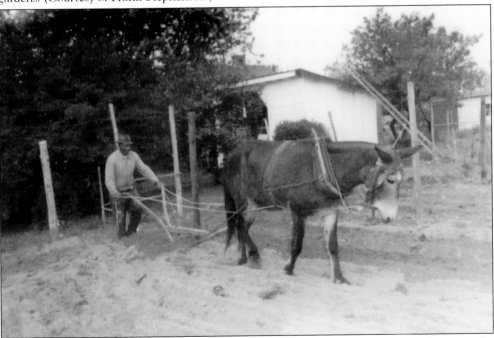

In the late winter months in eastern North Carolina, it was time to break up and prepare the family garden plot for planting. This 1950s photograph shows a man with a mule and breaking plow preparing rows in the garden. (Courtesy of Frank Stephenson.)

Cabbage, collards, beets, tomatoes, onions, carrots, Irish potatoes, and radishes were some of the vegetables grown in eastern North Carolina farm gardens, as seen here. (Photograph by Frank Stephenson.)

Eastern North Carolina farmers were adept at growing different kinds of crops, vegetables, and fruits such as watermelons to augment their family income. Some of these farm products were exported out of state, as seen in this 1961 photograph of trucks from Canada waiting in Murfreesboro to be loaded with watermelons. (Courtesy of Frank Stephenson.)

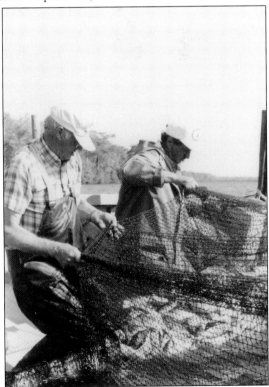

In the early spring of the year, river herring would migrate from the waters off the Canadian maritime provinces by the millions to spawn in the bourbon-colored waters of the rivers and creeks of eastern North Carolina. For centuries, the herring have been a free source of food for eastern North Carolina farmers and other residents. During the herring fishing season, various devices such as pound nets, gill nets, wire traps, and dip nets were utilized to catch the silvery-colored fish. The herring were caught for immediate consumption or salted down for later consumption, sometimes as a food supply in the case of a poor crop year. Here, herring fishermen Tony Stephenson and Lynn Harrell roll herring into their boat from one of their Chowan River pound nets. (Photograph by Frank Stephenson.)

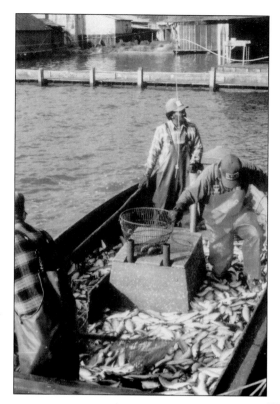

During the herring fishing season, some farmers along the Chowan, Roanoke, and other eastern North Carolina rivers and streams would supplement their family income by fishing for river herring. The farmers, like the ones shown here in 1970, would sell their herring catches to local and regional fisheries such as Perry-Wynns Fish Company, known as the "world's largest herring processing plant," which was located in Colerain on the Chowan River. (Photograph by Frank Stephenson.)

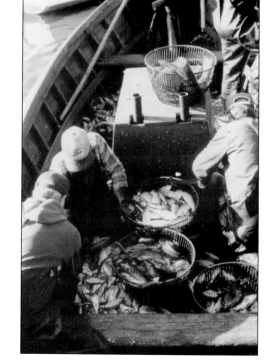

Chowan County farmers are shown here unloading their herring catch at the Perry-Wynns Fish Company in Colerain in 1970. (Photograph by Frank Stephenson.)

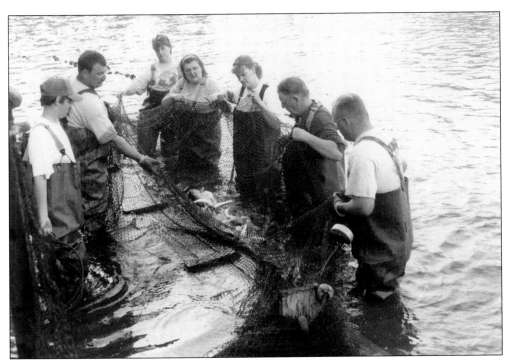

Many rivers and creeks in eastern North Carolina were the locations of herring haul, or drag, seines, including the Williams haul seine, located on the Meherrin River near Murfreesboro. Eastern North Carolina farmers and other residents could purchase river herring there by the hundreds to salt down for future use. (Photograph by Frank Stephenson.)

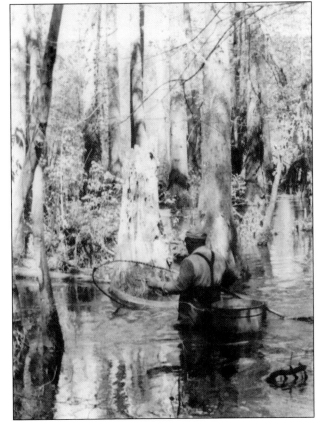

Many eastern North Carolina farmers would use large dip nets called bow nets to catch river herring, either for immediate family use or for salting down for future consumption. This eastern North Carolina farmer is dipping herring in Vaughan's Creek just north of Murfreesboro. (Photograph by Frank Stephenson.)

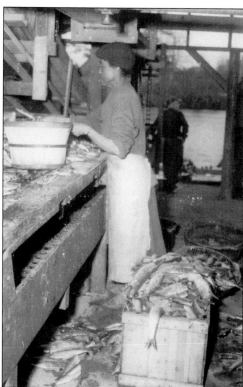

Many of the herring fisheries that were located on the rivers and creeks of eastern North Carolina provided seasonal employment for farm women who worked as herring cutters during the herring fishing season, from March to May of each spring. (Courtesy of Frank Stephenson.)

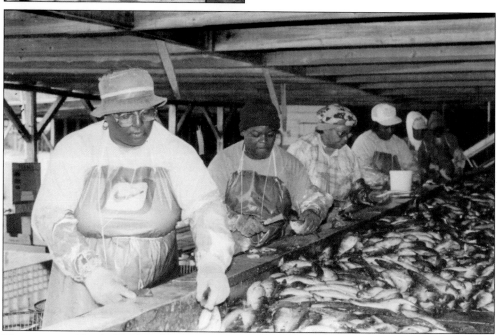

These eastern North Carolina farm women found seasonal employment as herring cutters at the Perry-Wynns Fish Company, the "world's largest herring processing plant," located in Colerain on the Chowan River. In September 2003, the Perry-Wynns Fish Company was destroyed by Hurricane Isabel. (Photograph by Frank Stephenson.)

Seven

GOOD TIMES, HARD TIMES

Monday was wash day for many eastern North Carolina farm families, as seen in this 1970s photograph. (Courtesy of Frank Stephenson.)

Many eastern North Carolina farm families took advantage of the good weather of the region to enjoy outdoor cookouts and birthday parties, such as this 1970 birthday party on the Ross Nichols farm in Hertford County. (Courtesy of Barbara Nichols Mulder.)

Many fine meals were cooked in wood-fired cook stoves in the homes of eastern North Carolina farm families, as seen in this 1970 photograph of the kitchen at the Ross Nichols home in Hertford County. Wood-fired cook stoves were utilized for many years before electricity reached the family farms of eastern North Carolina. (Courtesy of Barbara Nichols Mulder.)

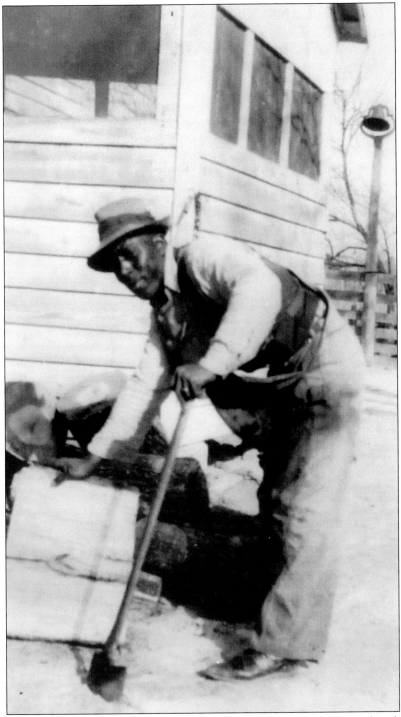

For years, many eastern North Carolina farm families relied on wood to heat their homes and to cook with. Trees were sawed down and cut into blocks that were brought to the farmhouse, where they were split into pieces that would fit in the wood heaters and stoves of the home, as seen in this Northampton County photograph. (Courtesy of Renee Tyree.)

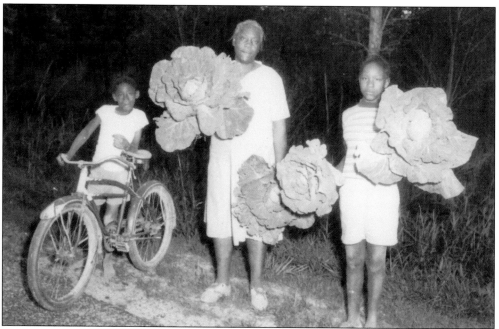

Eastern North Carolina farm families enjoyed the bounties of their farms and gardens, which produced a variety of vegetables, such as the large cabbage shown in this 1950s Northampton County photograph. (Courtesy of Frank Stephenson.)

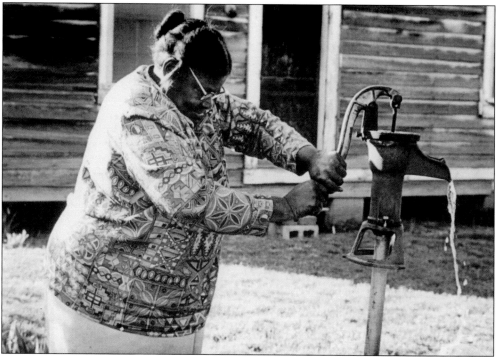

Many eastern North Carolina farm families did not have the luxury of electricity and running water in their homes. The old-fashioned hand pump was their chief source of water, as seen in this 1980s Northampton County photograph. (Courtesy of Renee Tyree.)

Many eastern North Carolina farm families were blessed with a number of children, who would begin working in the fields at a young age. This is a late-1940s photograph of farm children in Hertford County. (Courtesy of Frank Stephenson.)

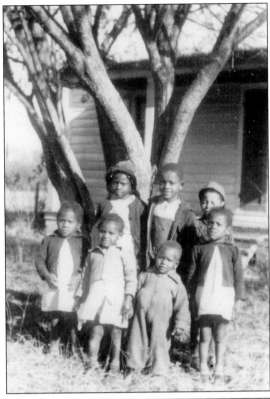

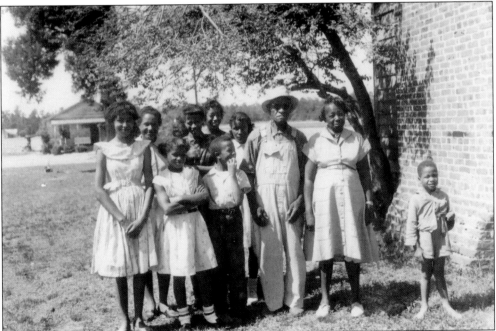

In the 1950s, a Bertie County farmer and his family pose for a photograph. The Smallwood family, shown here, worked on farms in both Bertie and Hertford Counties. (Courtesy of Frank Stephenson.)

The old wringer washing machine seen in this late-1960s photograph of Terri Nichols was a step up from the old iron wash pot used by many farm families. Prior to the introduction of the wringer washer, many farm families washed their clothes by hand, boiling them outdoors in an iron wash pot and scrubbing them on a scrub board, or washboard. Since no electric dryers were available at the time, the boiled and washed clothes were then hung outdoors to dry. (Courtesy of Barbara Nichols Mulder.)

In addition to canning and preserving, eastern North Carolina farm families came to rely heavily on freezers to provide food for their families year-round, as seen in this 1950s photograph of Lattie Mae Cooke Colson of Bertie County retrieving frozen items from the family freezer. (Courtesy of Barbara Nichols Mulder.)

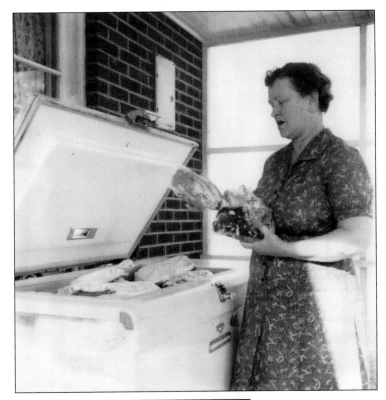

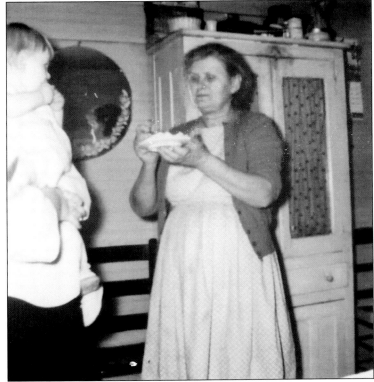

Mothers were the rocks of eastern North Carolina farm families, as they wanted nothing but the best for their families. Eastern North Carolina farm mothers were, and are, some of the most caring, sharing, and giving people, as seen in this late-1960s photograph of Velner Cooke Nichols feeding her granddaughter Beverly Nichols. (Courtesy of Barbara Nichols Mulder.)

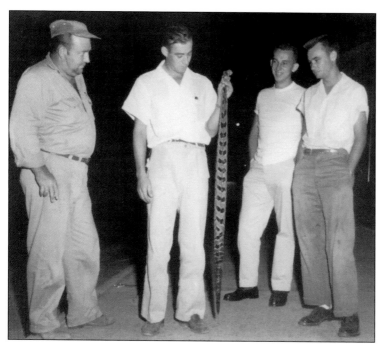

Over the years, eastern North Carolina farm families developed a second sense about where they put their hands and feet, for fear of being bitten by bugs, spiders, or poisonous snakes, such as this rattlesnake that was killed on a farm near Murfreesboro in the mid-1950s. From left to right are Dusty Warren, Sydney Deanes, Joseph Pierce, and an unidentified person. (Courtesy of Frank Stephenson.)

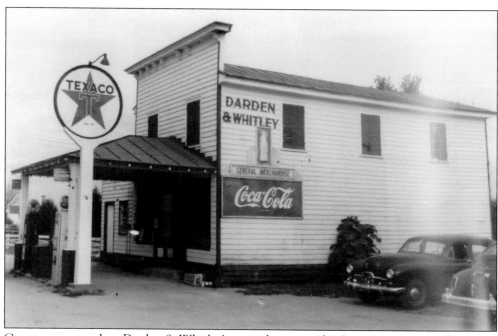

Country stores such as Darden & Whitley's general store, in the Como community of Hertford County, were scattered all across eastern North Carolina. These stores were often gathering places for rural communities, where information, news, and ideas were exchanged. A few country stores also served as post offices and polling places. (Courtesy of Frank Stephenson.)

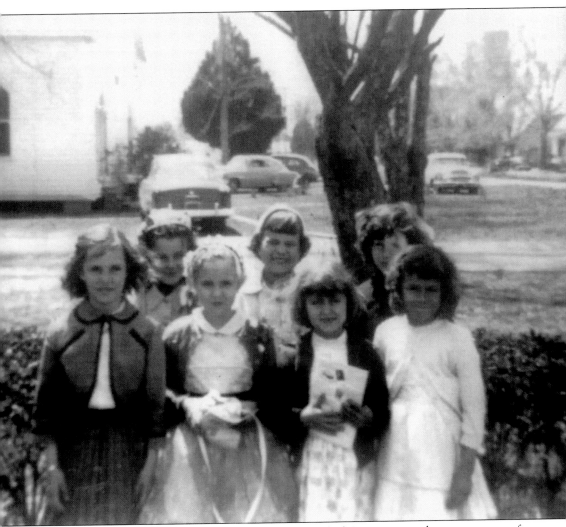

Country churches, such as Earlys Baptist Church in Hertford County, were the cornerstones of eastern North Carolina farm communities. These rural churches provided comfort and support for farm families during both the good and bad times of farm life. In the mid-1950s, Easter was observed at Earlys Baptist Church by, from left to right, (first row) Joyce Dean Nichols, Joyce Ann Nichols, Delores Nichols, and Jane Ellen Vick; (second row) Masie Harrell, Audrey Britton, and Barbara Nichols. (Courtesy of Barbara Nichols Mulder.)

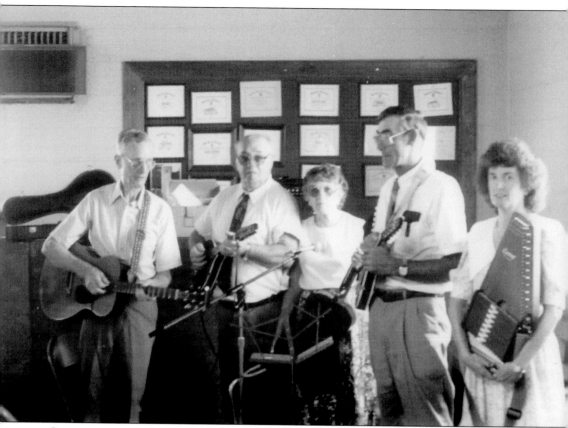

Some eastern North Carolina farm communities had very talented musical groups, including the Como Ramblers, from the Como community of Hertford County. The group was comprised of, from left to right, Dukes Griffith, Mr. and Mrs. George Racette, Quinton Jenkins, and Beth Jenkins. (Photograph by Frank Stephenson.)

Wells were one source of water for many eastern North Carolina farm families. Some wells had the chain-pulled-bucket method of retrieving water, while others utilized a well sweep to pull the bucket full of water to the surface, as seen in this 1966 photograph of the Thad Vann farm in Hertford County. (Photograph by Frank Stephenson.)

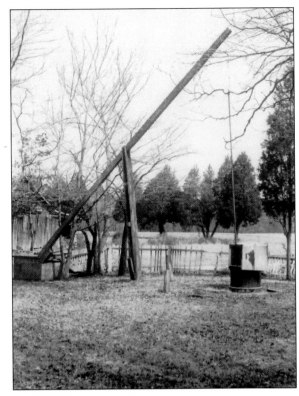

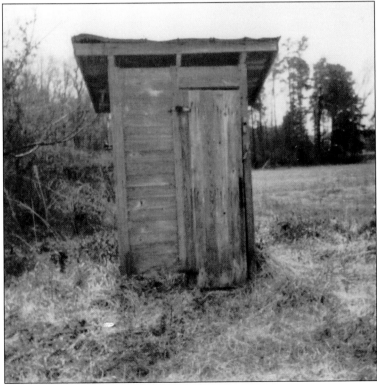

Many people who grew up on small family farms in eastern North Carolina no doubt have memories of outdoor toilets, which were commonplace long before indoor plumbing came to the area. (Courtesy of Barbara Nichols Mulder.)

Eastern North Carolina farmers were adept at finding ways to protect and conserve their farm resources, such as runt pigs, little pigs that were castoffs from the their original litters. One such farmer was Jerry Newsome of Hertford County, shown here in the 1960s with a substitute sow to feed the little pigs. This device, often called a runt pig feeder, used powdered milk and baby-bottle nipples to plug up the little porkers. (Courtesy of Frank Stephenson.)

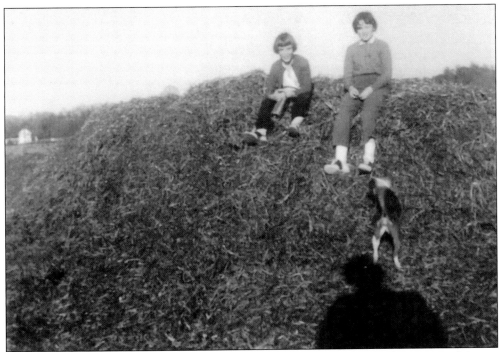

Many children who grew up on eastern North Carolina farms have very fond memories of playing on a huge pike of harvested peanut vines, as seen in this early-1960s photograph of Beth Stephenson Jenkins (left) and Deborah Stephenson. (Courtesy of Beth Stephenson Jenkins.)

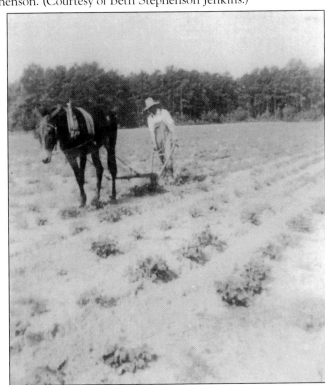

Plowing the fields with a mule and plow in eastern North Carolina was a long and hard task, as seen in this 1938 photograph of E.E. Vann of Murfreesboro plowing his peanut field. (Courtesy of Don Vann.)

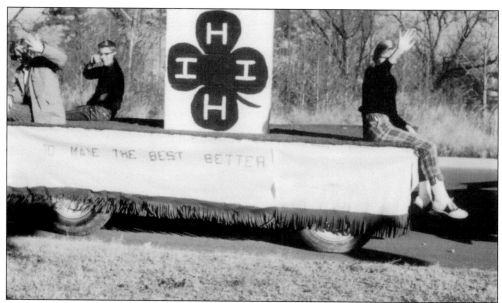

Hundreds of thousands of eastern North Carolina farm children enjoyed great experiences while growing up as members of their local 4-H clubs. Summer camps; farm, home, and garden projects; and local, district, and state competitions provided unusual opportunities for eastern North Carolina 4-H club members. Local parades often featured a 4-H club float, as seen in this 1950s photograph of a parade in Ahoskie. (Courtesy of Hertford County Agricultural Extension Service.)

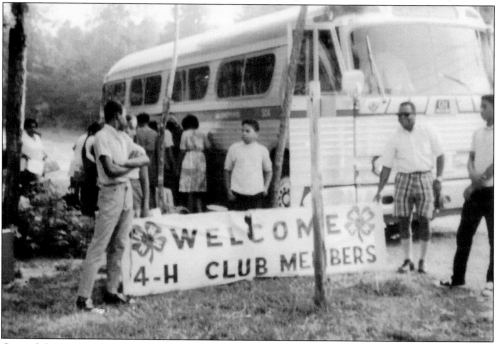

One of the greatest experiences that eastern North Carolina farm children enjoyed as 4-H club members was the opportunity to attend 4-H camp in the summer, seen in this 1950s photograph. The summer camps were scattered across North Carolina, from the mountains to the coast. (Courtesy of Hertford County Agricultural Extension Service.)

Many North Carolina 4-H club members participated in the annual livestock shows and sales that were held across the eastern part of the state. Seen here in the 1950s is the Hertford County 4-H livestock show. As participants in these shows, 4-H club members would raise hogs, beef steers, dairy cows, goats, and lambs and exhibit them at the livestock show and sale, often winning ribbons and cash awards. (Courtesy of Hertford County Agricultural Extension Service.)

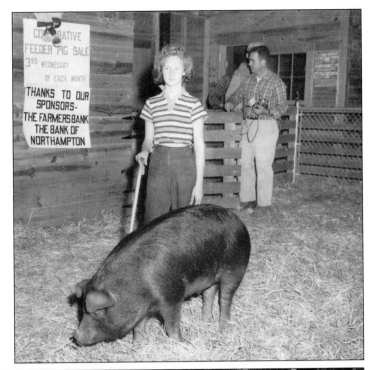

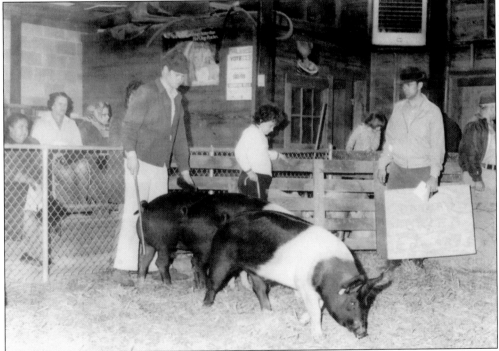

There were many valuable lessons, such as responsibility, hard work, and dedication, learned from being a participant in 4-H livestock shows and sales. In the 1950s, this Hertford County 4-H member entered two hogs in the annual livestock show and sale. (Courtesy of Hertford County Agricultural Extension Service.)

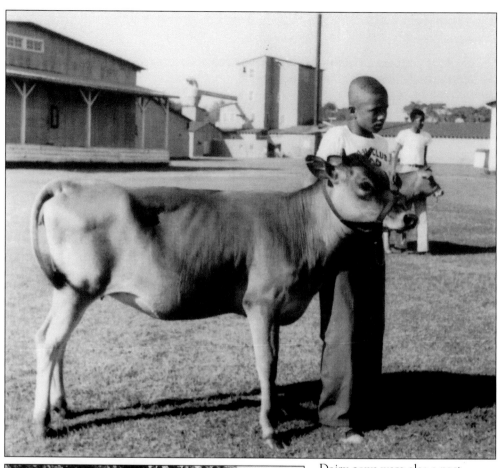

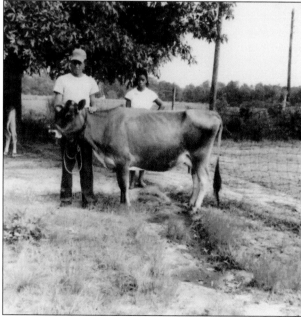

Dairy cows were also a part of the 4-H livestock shows and sales, as seen in this 1950s photograph of Hertford County 4-H club members and their livestock show entries. (Courtesy of Hertford County Agricultural Extension Service.)

A Hertford County 4-H club member, with the assistance of his father, proudly displays his entry into a 4-H livestock show in the 1950s. (Courtesy of Hertford County Agricultural Extension Service.)

A group of Hertford County 4-H club members await the livestock judges' decision in this 1950s photograph. (Courtesy of Hertford County Agricultural Extension Service.)

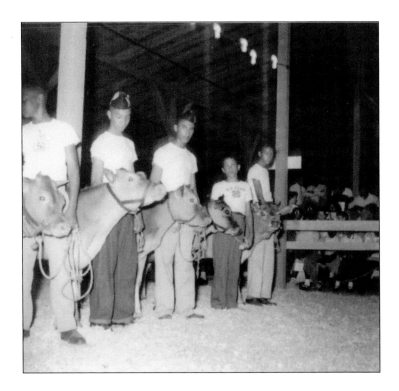

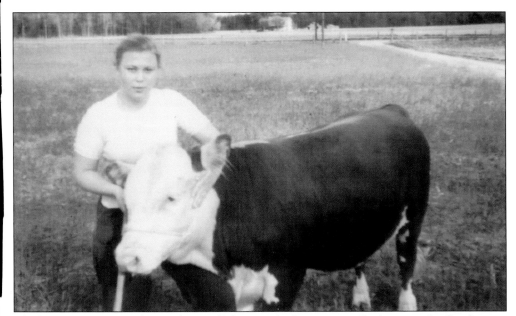

The largest entries into the 4-H livestock shows and sales were usually the steers. Joy Stephenson of Hertford County is seen here in the mid-1950s with her well-groomed steer. All of the entries in the 4-H livestock shows required a huge amount of time and work on the part of the individual 4-H club members, feeding, training, and grooming the animals. (Courtesy of Hertford County Agricultural Extension Service.)

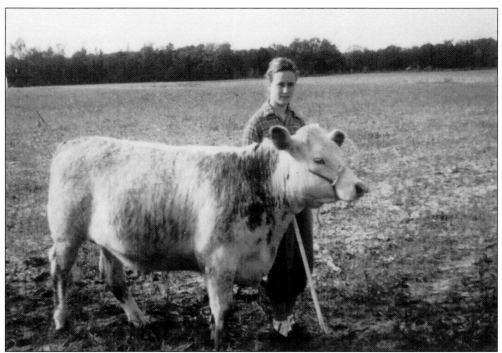

Hertford County 4-H club member Mary Lois Cullipher proudly displays her entry in a 4-H livestock show and sale in the mid-1950s. (Courtesy of Hertford County Agricultural Extension Service.)

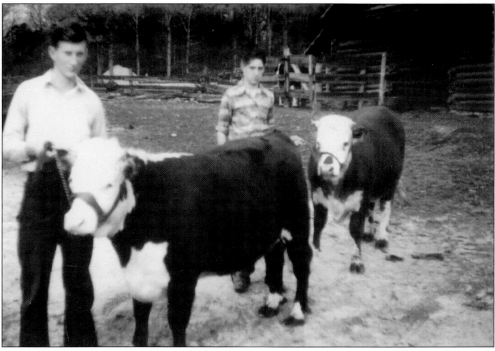

In this 1950s photograph, two Hertford County 4-H club members proudly display their well-groomed steers, which were entered in the 4-H livestock show and sale. (Courtesy of Hertford County Agricultural Extension Service.)

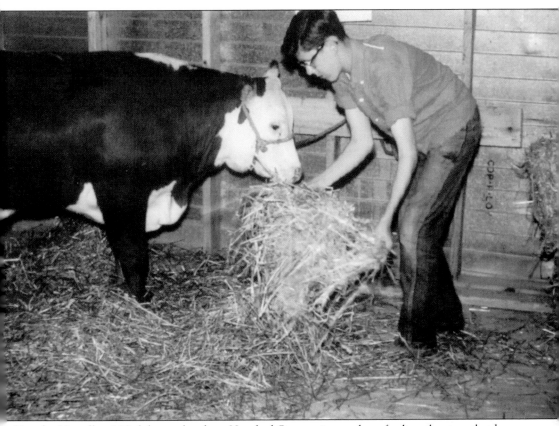

Douglas Howell, a 4-H club member from Hertford County, is seen here feeding the steer that he has entered into a 4-H livestock show and sale in the late 1950s. (Courtesy of Hertford County Agricultural Extension Service.)

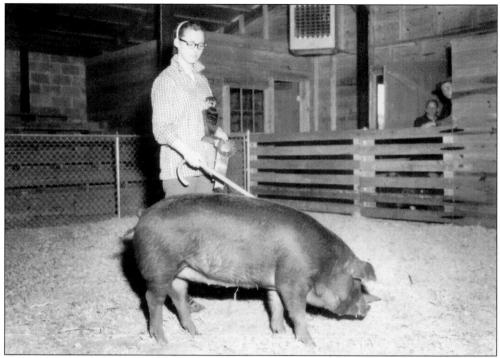

This Hertford County 4-H club member proudly displays the ribbon and trophy she won in a 4-H livestock competition in Murfreesboro in the 1950s. (Courtesy of Hertford County Agricultural Extension Service.)

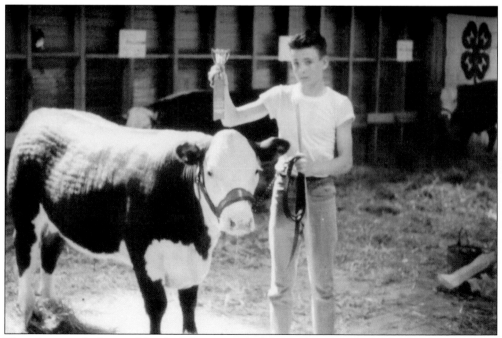

This photograph shows a Hertford County 4-H club member proudly displaying the ribbon he won in the steer competition. (Courtesy of Hertford County Agricultural Extension Service.)

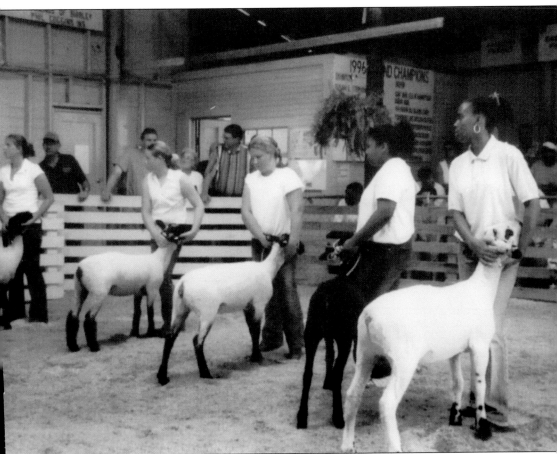

The 4-H shows and sales were not limited to cattle and swine. Lambs and goats were also a part of the competition. (Courtesy of Hertford County Agricultural Extension Service.)

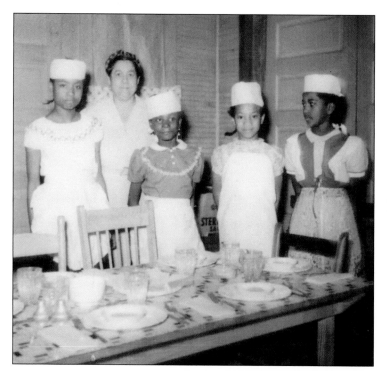

Girls who were 4-H club members experienced many activities, such as time management, food preparation, and budget issues, that would be very valuable and useful when they had their own homes. (Courtesy of Hertford County Agricultural Extension Service.)

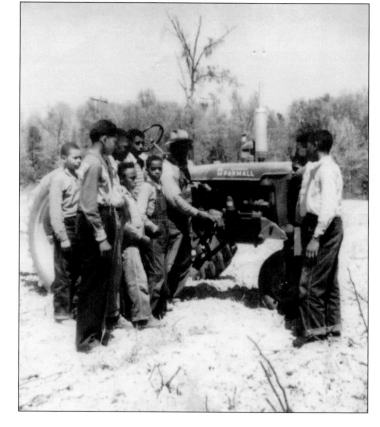

The operation and maintenance of tractors was one of the many activities that 4-H club members experienced, as seen in this 1950s photograph. (Courtesy of Hertford County Agricultural Extension Service.)

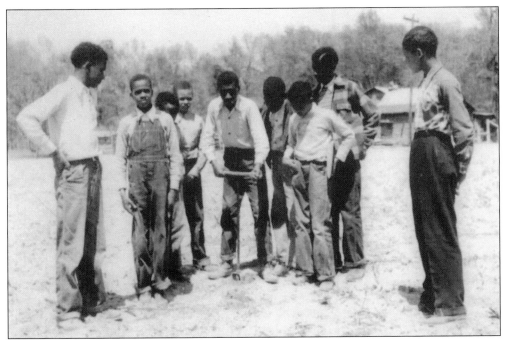

In this 1950s photograph, Hertford County 4-H club members are learning firsthand the proper use of a peanut pole auger. Peanut poles were used for many years on eastern North Carolina peanut farms to stack peanut vines for drying and curing prior to harvesting. (Courtesy of Hertford County Agricultural Extension Service.)

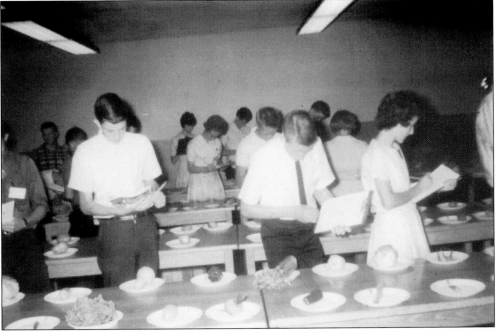

Food-judging competitions were another activity that 4-H offered its members, as seen in this 1950s photograph of a food-judging event in Hertford County. (Courtesy of Hertford County Agricultural Extension Service.)

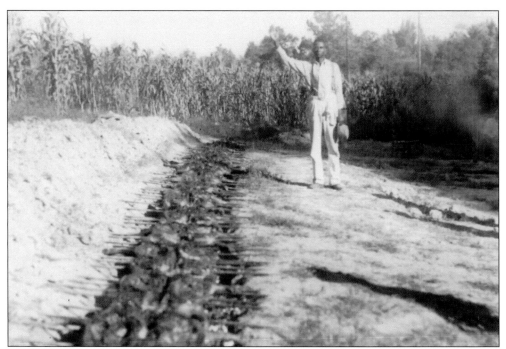

At times, eastern North Carolina farmers would pool their resources and efforts to sponsor events and raise money for different causes. One especially popular fundraising event was a barbecue, as seen in this 1950s photograph of pork being cooked over an earthen pit in Hertford County. (Courtesy of Frank Stephenson.)

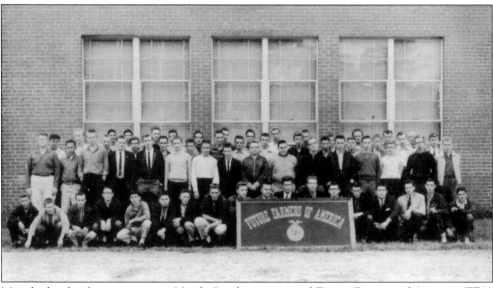

Most high schools across eastern North Carolina sponsored Future Farmers of America (FFA) chapters. The Conway High School chapter is seen here in 1961. FFA chapters provided high school boys with an opportunity to learn firsthand the skills, knowledge, and understanding of farming they would need to make it their livelihood. Thousands of former FFA members became successful farmers in eastern North Carolina. (Courtesy of Barbara Nichols Mulder.)

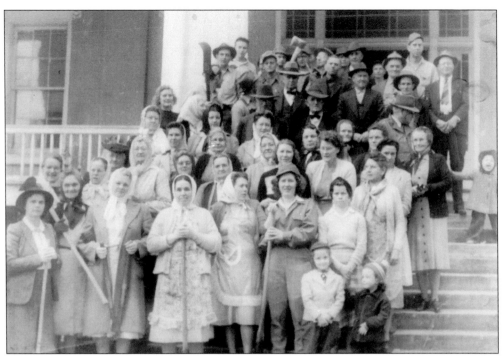

Eastern North Carolina farm families are some of the most generous and caring folks in the state, sharing freely of their time, talents, and resources for many different causes. An excellent example of this can be seen in this 1948 photograph of members of Hertford County Home Demonstration Clubs and their families involved in the cleanup effort leading to the reopening of Chowan College (now Chowan University) in 1949. The college had closed in 1943 primarily because of a lack of students caused by World War II. The photograph was taken on the front steps of the 1851 McDowell Columns Building. Today, Chowan University, located in Murfreesboro, is one of the fastest-growing universities in the South. (Courtesy of Hertford County Agricultural Extension Service.)

People who grew up on the farms of eastern North Carolina can attest to the hard work, hardships, and rewards of what some may view as a quiet and simple way of life. Sure, life on eastern North Carolina farms could at times be extremely difficult and tiring, but few people who lived it would trade the experience for anything. (Courtesy of Hertford County Agricultural Extension Service.)